Nataly

Enjoy the Smut!

MASTER
HAN'S
DAUGHTER

Also By Midori

The Seductive Art of Japanese Bondage
Wild Side Sex: The Book of Kink
The Toybag Guide to Foot & Shoe Worship

MASTER HAN'S DAUGHTER

BY
MIDORI

CIRCLET PRESS, INC.
CAMBRIDGE, MA

Master Han's Daughter
by Midori

First Edition June 2006

ISBN 1-885865-50-3
ISBN 13 978-1-885865-50-2

Circlet Press is distributed in the USA and Canada by SCB Distributors.
Circlet Press is distributed in the UK and Europe by Turnaround Ltd.
Circlet Press is distributed in Australia by Bulldog Books.

For a catalog, information about our other imprints, review copies, and other information, please write to:

Circlet Press, Inc.
1770 Massachusetts Avenue, #278
Cambridge, MA 02140

http://www.circlet.com

TABLE OF CONTENTS

MASTER HAN'S DAUGHTER
PART ONE

Floating slowly up from blissful soft black sleep, I come to the dim awareness of my wretched life. No need to open my eyes to know every inch of the cluttered steel container that I reluctantly call home. Hundreds of these stacked up on each other like a beehive, connected by lifts, gangways and catwalks. The sun barely ever penetrates this deep into the res towers. Then again, the sun doesn't often shine on ShinEdo—the synth isle showcase of Nippon's technological might. Most of us living here know that this is just a penal colony for the "nails that stick out." They just hammer us down into helplessness, into being wetware components of the giant zaibatsu info domain. I write code. Just another system jockey who works too damn long just to barely survive. When I can, I get high or get laid. Both cost a load of yen. I owe a lot of money to men with missing digits.

The java calms my morning nerves as I skim the white noise chatter off the net. Java, jack-in and jack off—my morning ritual. Live feed from Hong Kong Honeys is streaming steadily in the center of my visorscreen. I do love those barely legal Asian beauties. This morning it's Sofia from Seoul. Her stats read that she's she's a 21-year-old majoring in pre-nursing at a Catholic girls college. Yeah, sure. Two tight black braids with bows skim her firm tits. She's wearing a blue, pleated skirt with a sailor blouse and matching blue scarf, held by a sorority pin. White tube socks come just up to her knee. She has a Band-Aid on her left knee. Nice touch, doll face, like you got scraped on the volleyball court. More likely she's got rug burned knees from swallowing too many cocks last night at the girl corral.

Call me old-fashioned, but I'm crazy for those school uniforms.

Midori

She's sitting on the floor with one knee up, sucking on a lollipop. She's swinging her knee lazily from side to side and letting the wet sucker slurp in and out of her pink little lips. Her white cotton panties flash at me from time to time. I like it when they pretend that they're innocent. I like to pretend that I'm corrupting them. The truth is probably that I'm the naive one, clinging to some antiquated idea of innocent girls and their virginal tight pussies, and getting off on the thought that the look of pain and struggle when they're getting fucked is real.

She's swirling her tiny pink tongue around the candy, looking at me with eyes of well-practiced wide innocence. My cock stiffens. I slide the neuro adapter sheath onto my dick and neuro gloves on my hands. I see generic hands and the shadow of a throbbing cock on the edge of my visor.

Sofia grins. I hear her silver bell girl voice in my ear buds. "I'm here for my tutorial, Teacher. What will be my lessons today?"

Ooooh, yeah, Baby! This site really memorized my preferences so well. "Oh, yes, Miss Sofia, I have some very important lessons for you to learn today. It might be painful but you'll thank me in the end. First I must give you a thorough physical exam. Come over here, now!"

God, I'm such a little pervert. The hands on my screen loom larger as she comes in closer. I wrap my arms around air and feel her virtual skin. Her tiny shoulders fit into my hands. I pull her into me and feel the wool of her pleated skirt against my cock. My cock moves up to look for a non-existent wet hole. I feel the virtual thighs through the wool around my member. She gasps as I grab her hard into me. With a length of rough hemp rope I crudely tie her hands behind her back and run the rest of the rope around her chest, making her nipples protrude even through the sailor blouse. Then I grope her like some old man. I paw her perky tits and bite at them. I'm working fast this morning. I grab her left tit hard and knead it while with the other hand I'm feeling up her ass.

She squeals and giggles and protests. "Teacher, what are you doing? That hurts!"

"You're a big girl now. You can take more than that. Let me see more of you so I can give you a good, hard lesson." My hands slide under the blouse and feel the soft edges of a small cotton bra. The pattern is floral. I know that because that's what I request. I tweak her

10

nipples until she squeals with a high pitch. I press my mouth on to her honey-glossed lips and thrust my tongue down her candy-flavored throat to feel her smothered squeals in my mouth. The more she struggles the more she rubs against my aching cock. My other hand slides under the skirt and paws at the white cotton panties. My hips move and thrust into air as I feel my cock pump her soft thighs, poking at the wet spot in the panty crotch.

She keeps protesting and calling me teacher. I keep groping and humping. I slide my left hand under the elastic of the panties and feel for her slit. Wisps of hair on soft pussy skin don't hold back the juices. My right hand grasps the soft cotton training bra. With one swift motion I rip off her bra and plunge two fat fingers up her cunt. She screams into my mouth. There's nothing like a good neuro interlock program to get me horny as hell. I push her back and get on top of her, pushing her legs aside. Her blouse pulled up, askew off her tit and straining against the rope, her skirt around her waist and her panties wet.

She still has that sweet, scared face. One hand mauling her breast, with the other I pull the wet crotch cotton aside. I don't even bother to take them off of her. Somewhere in my head I hear the sound of a zipper being undone. Next thing I feel is the soft, warm flesh of wet, young pussy against my swelling head. Her cunt lips are small and dainty. Her hairless lips are tightly clamped together with cunt cream flowing out just at the bottom. My dick head slides up and down along her gash as I slowly push into her. Her lips part and I feel heat. As I push harder, I feel my head opening her tight twat. She's really tight. Just as I break through I feel a wave of warm juices gush over my dick and I slide into her tight hole. I hear her scream somewhere far away. I sit back and pull her little body on top of mine. She hardly weighs anything as she's speared on my hard cock.

Her sounds of fear shift to moans as she begins to grind into me. "Oh, teacher, oh, you make me feel so good! Oh, yes, fuck your dirty little co-ed!" She bounces on my dick, and I feel her wet silk cunt grab my nearly bursting cock. The sweet little girl likes it and talks nastier as my veins throb faster. "Let me be your slut!" She screams as she grinds on my dick. Her little breasts with finger welts bounce just before my lips. Her braids have come undone and her hair flies furiously. She's grinding harder and harder. Her pussy's so hot and her mouth so filthy, I can't stand it anymore. Her cunt's pumping and

Midori

sucking at my dick, pulling all of me into her. "Fuck me harder, teacher, I'm your little whore! My cunt is so hungry for you. Dump your come in me!"

I lose it. I gush and pump deep into her tightness.

Sofia's image flickers a bit as some of the neuro adapters fall loose from my wilting dick. My belly and chest is covered in warm splooge. Sophia is on her hands and knees saying something to me, but I got what I needed from her this morning. She now registers in my mind as much as another tropical vacation commercial. The pampered life on a warm relaxing beach without a care, or the indulgent life fucking the light out of my own sex-crazed bitch for free. Both comforts far away and unattainable in my ShinEdo-bound life. Flipping my visor off, I deal with cleaning off my belly, feeling a vague desolate emptiness in my gut. It's bad enough that my java's now cold.

As I scan the usual traffic of news and gossip from the various worlds I care to know about, something a bit unusual catches my attention. Jiro, my dealer, tells me Master Han is looking for a husband for his only daughter, Mai. Huh? That praying mantis needs no help in finding herself a man.

Everyone's seen her around the clubs here, always flanked by a small army of bulky, dark-suited men in designer shades and designer firepower. The girl can fly and party anywhere, Shanghai, Amsterdam, Buenos Aires, etc... but rumor has it that she prefers ShinEdo, where she grew up. She likes to cruise the clubs, junkie houses and bod mod shops for her next amusement. "Hunting for prey" is an apt description of her nocturnal hobby. Miss Mai, as she is reverentially referred to, is a tightly muscled and well detailed high femme with golden cobra eyes, cocaine white skin and blood red lips. To say that her sexual appetite is voracious may be slightly misleading. She was born under a bad star omen and she stays true to her cursed sign. The prophecy states that Fire Horses devour men, are untamable, and leave a trail of destruction behind. It is also said that they are endowed with mind-blowing sensuality and alluring beauty. All of which are true of Miss Mai.

Everything about her is long and lean. Her gorgeous legs seem to go on for miles under the side slit of her signature chongsam. On those long legs she moves through this congested and chaotic world with the liquid grace of a forest cat. A languid gaze from her gold and onyx eyes transfixes the victim of her affections to suspended con-

sciousness. Knee length blue-black hair, immaculately oiled and shined to a lacquered high luster, is always coiffed into intricate braids and coils, reminiscent of the Dynastic ladies of a millennium past, though what electronic and electrorganic devices she has imbedded in the courtly 'do' is anyone's guess. Thin, small hands extend to long spidery fingers, which in turn sprout vicious talon-like nails capped with sharpened titanium tips. Rumor has it that her claws are sharpened to cut flesh with ease. This latter is more a comment on her love life than her dining habits.

Miss Mai consumes sex. Her appetite for sex is now legendary among us low lifes and metro dwellers. She goes out with her entourage of servants, hangers-on of indeterminate gender and hunting mates just to catch a new amusement. With her stunning beauty she easily attracts new little sex toys each night at her various hangouts. The word on the street is that she's heroin on two legs—a mind-blowing lay like Aphrodite and the priestess whores of the Raj combined. Her tight cunt's supposed to move and fuck like it's got a tongue and a pair of hands inside it.

She'll take her chosen morsels back to her Shinjuku lair and use them for days. The only problem is that if the sex bores her before she's fully sated, she has a habit of tying up her exhausted sex toys and slicing off strips of their flesh with her talons to consume them like thin strips of fine Kobe beef tartar. I've even heard that she has a large food disposal unit in her bedchamber to "clean off her plate." Of course all of this is just gossip on the ether, since I just don't rate enough to know anyone who fucked the bitch and told about it or even someone who fucked her and didn't live to tell about it. Although I'd guess that she's a much finer lay than any joyride a neurosheath or low-grade sexmorph hooker's ever given me. Damn, she must be fine.

Miss Mai is the beloved only daughter of Master Han, one of the biggest names in organized psychopharmacological industries—yeah, he's one of the prime dealers this side of Beijing. My dopeboy Jiro's one of his countless pathetic little street punks. A direct descendent of one of the 19th Century opium lords, Master Han still adheres to the old ways of the Continent, even though his operation HQ and lab relocated long ago to a barren, fortress-like compound on an island off Hokkaido. On the other hand, the cold and forbidding new capitol of the opiate empire does resemble pre-American Manchu a

Midori

great deal. Master Han may be a ruthless overlord in the viper pit world of narcotics, but he is also one of the most doting fathers to ever walk this earth. He actually thinks that his daughter's murderous, depraved lust is "adorable." Her father's position, power and obsessive doting is also why everyone addresses that sex cannibal with the obligatory title of "Miss."

Later that night I hook up with Jiro at the izakaya over a beer. I want to know the scoop. "What's up with the husband search for the flesh-eating princess?" I ask as I push a tall cold one across the table to him.

"Well, you know, Master Han's not getting any younger. He's looking for an heir to his throne now." He's gulping down the brew like a man dying in the desert.

"So what's wrong with Miss Mai?"

"She doesn't want the job. She just wants to play. Master Han's fine with that, but that still leaves him without an heir."

"So he's looking for a husband for her to be the heir?"

"Not exactly." He belches between swigs. I order him another beer to keep him talking. Obviously I'm paying for the info with a meal and brews.

"Master Han wants Miss Mai to breed. You know, he's all about the Old ways. He wants to keep the bloodline. Of course she wants nothing to do with carrying it or raising it. But she's willing to fuck and have the embryo transplanted to a synthwomb. The new lord will be raised by the estate, I'm sure."

"So why the search? She's got plenty of breeder boys to pop." Fiddling with some edamame, I try to hide my impatience.

"Master Han's gotta clear the donor through genetic testing. He wants a good combination with Miss Mai's genetic temperament to make a good leader. So he's looking for a husband candidate with the right double helix."

Great, I thought. He's trying to custom breed a Genghis Khan with an appetite for flesh. This is an arranged marriage of the DNA—a biotech omiai.

As he wolfs down the food from various small plates he manages to tell me that once the husband candidate clears the gauntlet of the geneticist, he has to pass the test of satisfying Miss Mai. I guess that last hurdle was set by the bitch herself. Although Master Han probably sees that any man who can sate her and survive must have strength

in character, creativity, stamina and a steel will to survive. All auspicious traits for the next drug lord of the Far East. The only thing that will be different for this lucky survivor from any other nightly conquest of hers is that he's going to be set for life. Master Han's ancestral duty and filial responsibility is to honor the father of his heir for the rest of his natural life. This dude will get to live the life of luxury, fuck Miss Mai from time to time (that is if she'll have him), and have the choice of whatever drug he wants, whenever he wants it. Best of all, he'll be beyond the stranglehold of any law or zaibatsu powers. By the edict of the Old ways, he could even have concubines! A harem!

I sure wouldn't mind fucking the minx and getting out of this dump. My mind starts to wander an infinitely huge mansion filled with an endless supply of the highest grade drugs and willing, fuckable women—just for me.

Yeah, right. I take a long pull on the beer. I'd better enjoy the Sapporo, since that's a more real thing than any drug-and-babe-filled pad could ever be to me.

"Jiro, come clean with me. What's in it for you? There's gotta be a reason why you're telling this to me. You're never one to just shoot the breeze unless it smells of yen."

Jiro grins. "Of course, buddy. There's a big wad of yen in it for me if I snare the right scumbag. And I think you just might be that meal ticket for me."

I resent being called a scumbag, but since what they're after is my jizz, I guess scumbag just about sums me up. It costs me more food and beer to get all the relevant information out of him. I never knew this punk had such an appetite. Afterwards I wander the urine-stinking back streets of ShinEdo. Blue green lights from the windows of dilapidated res towers, green and orange neon signs of bod mod joints, and the bright marquees of cheesy, legal bordellos all mix and melt in the oil-slicked puddles in the streets of my pathetic 'hood.

Everyone here is looking to score, to get off, and to be happy for a little while, and I am no different.

AYA'S BLADE

The hilt dug into her weary calf. She caressed the outline of the blade through the boot leather—an ancient cold sliver given to her by her father, and given to him by his father, and... A well-practiced motion by now, each time bringing her a sense of comfort and calm whenever the storm rages inside her. Something his voice used to do for her, but now there is only his blade. Aya let her throbbing head sink heavily back into the dark-stained leather of a dilapidated armchair in a decrepit bar.

Dex's body had been even more perfect in the honey-colored light of those afternoons. The flak jacket thrown in the corner, followed by one swift motion to peel off the tight black T, and her lean body would open up to hold Aya.

Dex's powerful arms wrap around her, as searching hands roam to learn each curve, and hungry lips devour her pale shoulders. On Dex, the tight six pack abs and sculpted shoulders frame perfectly the small, firm and defiant breasts. So breathtaking, thinks Aya, that she wishes she could gaze upon Dex for ever... that the moment would last for ever.
(It never does, of course.)

A month since Dex disappeared. A month since Mr. Y sent Aya out to hunt her down. Thirty-two days and eight hours since Dex's knowing hands last caressed her.... Or maybe it was an eternity. What was the difference? All she needed to worry about right now was to right the wrong... to settle the family business and save face. Somewhere here in ShinEdo Dex was hiding—hiding from the consequences of disloyalty to the Family. Mr. Y was right. It was Aya's fault for allowing

Midori

A the infiltration. Love, ignorance or weakness, he didn't care and he
y didn't ask. But he did demand a price. Dex would never speak such
a heresy again. To ensure Dex's silence, he ordered Aya to fetch him her
tongue. She reminded herself of the surgical sharpness of her father's
s blade. Perhaps it was Mr. Y's fatherly fondness for Aya that spared Dex's
life.

B
l *With the swift hands of a thief Dex disrobes Aya. Whether the silken kimono or the*
a *street-battle Kevlar, they would all be inconsequential piles on the floor of the Family*
d *compound. Dex lays Aya on the deep futon as if she were the most divine tapestry and*
e *gazes upon her. Aya feels the irezumi ink come alive on the snow-white flesh under Dex's*
 gaze. The flames, the dragon and the Kannon on her back glow anew. The waves, clouds and
 windblown cherry blossoms on her limbs quiver. But most of all, the orchid hammered
 into her own flesh petals sways and swells. Parting open this swelling desire of Aya's flesh,
 slowly Dex buries her face, taking in the heady scent, drinking all that she can and explor-
 ing each delicate petal with her probing tongue. The deeper Dex dives, the higher Aya flies.

Aya lifted her lead-weight body from the chair and cleared her tab
with the barkeep. She slid back into her riding armor and headed into
the bleak, neon-lit darkness where her metal steed waited. Another
night spent searching for the dirty needle in this filthy haystack.
Another night of feeling the sting of betrayal and the hollowness of
longing.

A cascade of blue-black spills over the white downy pillows as Aya throws her head
back. Pale blue veins throb along the taut length of her throat. Her eyes press tightly shut
to keep her from exploding into nothingness as pleasure overwhelms her. Dex's body
weighs down upon her burning flesh, pushing her into the futon with each thrust. Strong
butch hands pin her shoulders down, keeping her from flying into a thousand ecstatic
pieces. From Aya's twisted, crimson-smeared lips cries of rapturous demons and ravished
angels escape. Dex's lips cover the growling abyss and devour Aya's pleasure.

By now she hunted by instinct. She followed the scent, a primal
scent known only by lovers who have consumed each other to the
core. Broken hearts only make the scent grow stronger, like blood in
the water.

Even so, Dex eluded her, slipping away and beyond her, sometimes
just by moments. How many bars, air shacks and freak joints had she
walked into, jacked up the muscle goons to find out that Dex had just

vanished through some back door? Obviously the prey knew the scent of the predator just as well.

Tonight her bike seemed to know the way. She let it lead, as it took her hand like the ouija, spelling out mysteries on the night road. Warm rain streaked down the visor, as a bit of fog inside the gray plexi smeared the pale blue GPS chatter. She thought about getting the helmet fixed. She no longer noticed the streams of tears that silently flowed out to join the steady summer rain.

Dodging piles of burning trash and chemical spills she found her self in Otoko-machi. The place reeked of stale piss and sour Y-chrome come. Haggard faces barely old enough to leave childhood behind turned from dark corners to see if a meal ticket had just ridden in. Sensing a double X, they soon lost interest and faded like ghosts back into their doped oblivion. Surely Dex couldn't be there.

Yet Aya's hair seemed to stand on end. Something tugged at her like a nightmare nearly remembered... Or was that a wet dream?

Aya's hands roam across Dex's taut flesh. Deep crimson talons dig into the muscled back, leaving angry red testaments to Aya's passion. At times Dex even seems to taunt her to mark deeper and harder, daring Aya to claim Dex as her own. Letting their lips brush in the heat of the passion, Dex pulls away from nearly given kisses, again and again. Desires inflamed in fury Aya throws Dex off of her, swiftly planting her small sharp hands on Dex's defiant throat, pushing her down on the tatami, crashing down onto her voraciously. Aya's hand steadily presses into Dex's throat, feeling for each throb in her veins, feeling for life and assurance of the moment. With Dex's pulse in her hands Aya plunders all the kisses she desires, until Dex's arms pulls her in tighter. Ravisher and the ravished, soon there's no difference as the self is lost in the feeding frenzy.

She dismounted and surveyed this discarded corner of ShinEdo with the calm regal eyes of Persephone in Hell. Clicking her helmet to night vision and sense alert, a swift move under her armored trench engaged the Kalashnikov. She glided quietly through the damp darkness, a black phantom floating into vision under the sickly yellow streetlights, then fading silently out again. First a bar, then a shooting gallery, and then a hustler joint. She even checked with the cold storage for the John and Jane Does. No Dex. Somehow, though, she just couldn't shake Dex's scent tonight. She continued through the twisting alley to yet another sleaze parlor.

Midori

Ripe figs, dark honey and soft musk. Ah, the intoxicating scent... Yes, that's what you're made of, thinks Aya as she greedily laps at Dex's engorged clit. Aya's head thrown over the edge of the futon, she nestles her head under Dex, between her bronze and steel thighs. Aya delights in the secret of Dex's body. Dex has never gone through any bod mod jobs. A bit old-fashioned and stubborn, she kept it all original issue, no inserts, no chems or hormones and certainly no retro-gene works. She honed her flesh by enduring the beatings on the streets and the mountain dojos. Sweet and sea-salted, unaltered juices flow down Aya's throat, and she drinks with a bottomless thirst for her lover. Crimson nails digging into the tight round ass, Aya pulls Dex harder onto her hungry mouth as Dex slowly grinds her cunt, waves of deep breath breaking and crashing into ragged gasps on the shores of Aya.

After half a dozen places, she'd begun to feel the old empty pit inside her gut, the same faded despair night after night. Honor is exhausting, but reprisal is tireless. She slid into another dark corner bar. A dive with no name except for a red neon chevron above a bleak black door in a graffiti-splattered black wall. The place reeked of man-sex and hot grease. A couple of dejected men in uniforms of the Frontiers War sat at the bar knocking back cheap whisky. A tow headed and emaciated boy, barely old enough for the Forces, stood near the piss trough. He wore the shirt of a colonel from the Northern Conflict, open to show his thin chest. He tweaked his nipples and stroked his eagerly padded cod-piece, advertising his desperate merchandise. Off in the back, beyond the blue haze of cheap cigar smoke, Aya could make out the outline of a hulking shirtless back in black leather chaps. The figure was framed by silver chains supporting a well-worn sling. The boot of another man on each side of his shoulders, his back heaved up and down with each thrust of his right arm. Sloppy slapping sounds mixed with the downbeat from the speakers.

She needs her inside her. She needs to devour and take Dex whole. Strong fingers lightly stroke her pulsing wet lips, teasing, teasing, teasing. Aya's cries grow louder and louder and she thrusts her hips toward Dex's hands in desperate hunger. Aya whimpers, feeling two sure fingers slide into her pulsing cunt. Her body writhes in agonizing pleasure. Her lips beg for more, her mouth moans for more. Dex slips in another, and then another. Soon all her digits are poised for the dark plunge. As Dex presses forward, Aya opens up. Eagerly at first, then suddenly halting, taking no more of her. Aya screams, feeling her own body in defiance to her desperate desire. Her entire being is overwhelmed by the single-minded need to consume Dex into her. She breathes a long cry and feels her hips, serpent-mouthed,

unhinge and open wider than her entire being. In an eternal blinding instant Dex's hand pushes though into her soul, filling her being in a white-hot big bang. Then she is no more, and yet, she is everything. She is both *Aya* and *Dex*.

Out of the corner of her eye she saw it—the shadow flicker of a body with mortal purpose. Before thought could float to the surface of Aya's brain, she'd crossed the bar in three swift steps and chased the leather-clad shadow out the blown-open back door to a rain drenched alley. In the sudden calm, beyond her weapon's sight lines, Aya saw her desire looking back at her from silent gray eyes.

The rain raged down like angry liquid steel. Deafening all.

Wordlessly, Aya stepped forward and planted the muzzle firmly in Dex's jugular, pushing her back, clanging the chainlink fence. In another soundless step, Aya pressed into Dex, weapon deeper in place. With the hunger of a lioness, Aya devoured Dex's mouth in gnawing kisses, probing deeply into her sweet lying mouth.

A moment's stillness enraptured.

In a frenzied second, three hands flew to zippers and buckles and snaps and one hand dropped the death steel into the oil-smeared puddle of that decaying alley. Dex kissed and bit at Aya's pearl-white neck as Aya slid her hand under Dex's flak suit to plunge into the dripping cunt. Moans escaped Dex's mouth as she rode Aya's demanding fingers. Aya greedily tore at her moans with hungry kisses. Sliding out of Dex, Aya smeared the wet silk juices on her fingers across Dex's face and licked it off. The taste of honey and figs exploded into her mouth. She pushed Dex down onto her knees, and she buckled right under, as Aya braced a foot onto the fence, tearing away a panel on her riding gear, exposing her steaming sex. Not missing a beat, Dex buried her face in Aya, making her grind, flying higher and higher... feeling the enormous wave of desire build and build and build and build until it crested and fell, crashing down on her in a shuddering explosion of tears and come.

Dex fed and drank and sucked and probed and fucked and ate at her lover warrior, tongue probing deeper and deeper...

Tears streamed down her flushed face as Aya reached for the hilt digging into her battle-weary calf.

Kitsune Gumi
A Dance with the Foxes

His face grated hard across the brick wall as another searing thrust reamed his ass deeper. His cry lost in the wind of the city and the cackling of the women, he struggled against his body, hating the betrayal of his own flesh against reason. He wanted to hate the pleasure he took from the beating and the fucking but he couldn't.

Earlier that evening, they had all watched him stroll into their dirty little bar in a rough corner of the Meat District like some precious royal prince on a jaunty little foxhunt. Maybe that made the denizens of the bar his downtrodden but loyal and admiring subjects? Aya rolled her eyes and glanced over to Dex sitting alongside her in the booth. Dex just snorted in disgust and tossed back another shot of whisky. They returned to voraciously devouring each other's tongues. Hands disappeared under the greasy table.

"I see that we're being graced with the presence of Mr. Handsome tonight," said Chin, absentmindedly coiling and uncoiling her steel mesh snake-whip around her gloved hand. Deep red nails from cut-off leatherclad fingers flashed in the smoke-filled half-darkness. The exiled Shaolin shifu, a Kung Fu master, shifted in bored restlessness. Her black titanium-weave chongsam fell away to show a glimpse of pale white legs scarred with angry red sword marks and Tong tattoos.

"He sure is pretty, though. I didn't figure he'd look so sweet off-line," said Shell, punctuating the comment with a low wolf whistle at the end, then flicking back her long platinum-bleached tresses to get a better look.

Kenji, the handsome prince in question, took a seat at the bar and

Midori

Kitsune Gumi

K chatted up the bartender, flashing his perfect smile. He seemed unaccompanied by the usual cronies, bodyguards or media crew, an unusual night out for this net darling of the moment. Sightings of what he wore, drank, ate, did, fucked, shot up, smoked, and uttered fed shows, blogs and games. The devout techno elite and fandom hackers could always take a ride on his neural net adventure hook up, whether realtime or delayed download. Broadcast depended on the fickle prince's mood and the power of his sponsors' almighty yen.

The black rubber and Kevlar body suit clung to his lean frame, accentuating the finely crafted and managed body. A long lion's mane of multi-colored dreads, sporting wires and jacks of all sorts, trailed down his back, hiding the jack-ports along the base of his skull and upper spine. He turned his smooth-skinned, caramel-colored face to scan the seedy bar. His beauty was incongruous with his bad-boy, arrogant bastard reputation. Japanese eyes and African lips smiled perfectly on a delicately graceful face, vaguely reminiscent of the gods of Syria or Egypt.

The five foxes leaned back in their booth and watched the prince prowl in their neck of the 'hood.

Her cold blue eye obliterated by the slow-rising white smoke of her Cuban cigar, Lady Blue piped in between smooth puffs "Yeah, Shell, he sure is your type. You want him tonight?" Lady Blue, the buxom blueblood with one blue eye, was the raunch-talking renegade daughter to one of the richest and most powerful businessman in Japan. She and her old man never much got along. He didn't much appreciate walking into his zaibatsu boardroom with biz partners for a big meeting to find the place littered with the bodies and booze from one of her massive orgies. Then there was the time that he tried to keep her from driving anywhere, so she blew up his car with a load of plastique.

Shell's black eyes narrowed into wicked little slits. "Sure, Lady Blue, how's about that one for tonight's 'featured guest?'"

Kenji had moved down to a table and leaned over a pretty little junkie who was obviously a-twitter with the meaningless attention. He let her fondle his built-up pecs.

"So you think he's going live tonight, data bagging or just solo and slummin'?" asked Aya. "I don't mind having him as our little 'guest du jour' but I have no desire for any of us to get logged onto his shows and getting our IDs blown around the net." Aya was always

careful about info security of her sister Foxes.

Shell slipped her visorcam on and clicked away in mid-air with chip-imbedded black-lacquered nails. "Aya, he's not Live now. He may be data-bagging for later air time, but you know, babe, I can jam him as quick as you can cut throat." Officially Shell was a dead woman. After so many tech convictions and consequent citizenship freezes, Shell simply let her self die of a well-documented suicide on the net and disappeared into ShinEdo. It made it easier for her to do what she did best. Hack for fun and profit. She was the tightest security and best access to info that the Foxes could ever imagine. In turn, the other Foxes took care of her, because she wasn't always so good at making her way around actual people in a non-virtual city. People didn't respond like programs and weren't so easily hacked.

"OK, it's done," said Shell, clicking out of her visorcam. "I've located his central unit. He's now fully rebroadcasting his trollopping day in his crib from a couple weeks back. I've also located his wheels, parked down the street. The security, recorders and GPS there are scrambled, too. So they're reading him somewhere outside Nagoya."

Dex grinned and waved down the half-metallized gendermorph waitron and ordered a round of drinks for her gang-mates. Dirty glasses sloshed onto the table with murky brown liquids in them, and they each raised their glasses in their ritual toast before a Hunt.

"To a fine piece of ass!"

"To blood!"

"To our pleasures!"

"To the Hunt!"

"To my sister Foxes!"

Bored with toying with the femme junkie, Kenji glanced toward the burst of hearty female laughter. Unfortunately for him, all he could see was the high back of the old vinyl-covered booth.

Dex checked for her piece in the belly belt holster, gave Aya a quick mauling and slipped out of the booth and disappeared though the back door, unseen by Kenji. Sauntering past the huddled forms of homeless dregs, she soon found Kenji's wheels parked between a juice joint and an illegal organ bank fronting as a fish shop. The boy had taste for serious retro Euro trash. A gleaming black, fully armored Benz McLaren hid in this ghetto as inconspicuously as a nun in a whorehouse. Dex didn't bother to scan the streets for witnesses nor the wheels for offensive security. Shell had already turned the alarms

Midori

Kitsune Gumi

off and Dex trusted Shell's skills for that. Dex didn't give a damn about witnesses anyway. This was their street and no one would mind her leaving the car accessible for the scavengers and thieves.

The silencer barely muffled Dex's hand cannon as she pumped round after round of hollow points loaded with fire-gel into the armor-plated tires. Even battle-tech wheels eventually collapsed against a close range assault with a predatory purpose. Dex turned on her heel and coolly strolled away, whistling a cheesy pop tune.

Aya and Chin stuck around the bar and started to give Kenji the mating eyes, sending him cheap drinks and holding his interest just a bit longer. Dex, done with her deed, cruised back into the bar, taking a seat alone in the far corner. At that cue Shell and Lady Blue strolled out of the bar, arm in arm like they didn't even know the other femmes.

"See you later, hot stuff!" Aya, much to Kenji's unaccustomed disappointment, blew him a kiss, grabbed her helmet and walked out. Chin shrugged, winked at him and followed Aya out the door. He didn't hear them laughing just outside the door.

Kenji downed the Kirin, dusted off his ego and paid up at the bar. When he turned the corner toward his car, he gasped and screamed like a pimp-slapped bitch. He wasn't prepared to find his armored baby cannibalized and made into a hollowed-out bonfire of molten rubber and sparking metal, the gull wings splayed out like a slaughtered bird. He tried to call his sponsors and bodyguards but none of his comm devices worked. He couldn't even bring up his eye cam to record the smoking mess. It pissed him off even more that he was losing the media op of his own juicy crime scene.

Loud rumbling filled the air and two bikes broke through the wall of black smoke, blinding him with their headlights. He froze for a moment, remembering that he was out of his element, in gang territory. From a crackling speaker of the red Gixxer 1500cc he heard a femme with a heavy Hong Kong accent: "Hey UpTown, got your self some trouble, huh?"

The other rider dismounted her Honda CBR, took off the mirror-visored helmet and shook out her waist-length black hair. Aya smiled sweetly as only a pampered yakuza princess could. "Hey, you're the one from the bar. Looks like you could use a lift. Hop on."

Relieved, Kenji hopped on the back of Aya's steed. Not so secretly he hoped that they might make an adventurous detour to wrap up

their earlier cruising and flirting.

He had no idea of the adventure awaiting him.

The two bikes sped through the twists and turns of the charred and scarred cityscape. Kenji held tight to Aya's back and enjoyed his growing wood between her leather and the vibrating engine. Inside the helmet Aya grinned and said something low and growling into the comm to the rest of the Foxes.

They took a sharp, boot-scraping turn into a dark alleyway and came to a screeching halt. Kenji jerked up onto Aya's back as her boot hit the asphalt.

Chin's speaker crackled and she barked. "Get off."

Somewhat dazed, he stumbled off the bike. He looked around to see the high brick walls of factories on three sides and a trash-strewn street behind him. They were in a dead end. Stench-filled steam rose from a grate, shadowing the figures walking toward him. One bare light bulb spread a jaundiced yellow glow through the alley as it swung in the growing wind.

Cold fear sank into his gut. If his dreads hadn't been weighed down with electronics, they would have stood on end. Out of the steam emerged the other three women, all decked out in leather and battle armor. He stumbled back, looking for a way out. The two riders circled around him, closing in like sharks on a bleeding surfer. They circled closer and closer, teasing him, frightening him, making him tumble and fall and scramble along the greasy asphalt. Then the bikes peeled away from him, opening up access for the three foot soldiers. He staggered to his feet.

Lady Blue strode swiftly in with long leather-clad legs, leaned into his unsteady body and decked him deep in the solar plexus with a gloved fist. Eyes popping in shock, he clutched at his chest, wheezing and gasping for air. The riders dismounted and joined the other women. The five moved in on their prey.

A gust of wind tore through the alley, obliterating his screams for help. No one came. Nobody in the 'hood cared anyhow.

A silver metal tongue flicked through the air and coiled around his long graceful neck. Chin pulled fast on her whip and Kenji tumbled backwards into Chin's blood-loving arms. Her black eyes glistened as she drank in his terror. As he gasped for air and clawed at the chain whip around his neck, she bent his head back and kissed his silently screaming mouth.

Midori

K **i** **t** **s** **u** **n** **e** **G** **u** **m** **i**

With one snap she spun him out like a child's top into Dex. Dex grabbed him by the thick dreads with one strong butch hand and forced him down onto his knees and held him there, his hands caught and wrenched behind his back by her other hand. Aya, laughing as clear as a crystal bell, stepped forward and pulled a silver sliver of a blade from her riding boot. Her long blue-black hair swept across her porcelain face with the growing wind. Grabbing the high neck of Kenji's body suit with her left hand she reached for his throat with her blade. Kenji tried to flinch back, but Dex had him held firm. Aya's blade sliced through his protective suit like it was rotten silk. It fell back to reveal a smooth hard-muscled chest and chiseled eight pack abs, but not quite showing his goods. Aya whistled, impressed with this fine specimen of masculinity. Then, with an evil grin she flicked her wrist and cut his chest. He groaned in pain. A trail of blood oozed from the gash. Aya leaned over, lapped the blood like a hungry kitten, kissed him full and deep on his mouth, letting him taste his own mortality.

His cock stirred.

Aya leaned up and kissed Dex hungrily, forcing Kenji into Aya's leather-wrapped tits. As she stepped back she kicked his legs out, bringing him down on his ass. Aya pinned his legs down.

Next, Shell moved in and growled low and mean into his face. She stared into his dilated eyes and clawed her black nails down his exposed chest, across the aching fresh wound and down to the pubes. Like a voracious spider, her hand pounced on his swelling package and she squeezed tight.

He cried out "No, pleasmfffff" but before he could finish pleading she shoved her tongue down his throat and gagged him with her black-rouged mouth.

His traitorous cock rose to meet her mauling hand. Shell felt his hard-on rise and grinned into the breath-sucking kiss. Disengaging her kiss, she snapped out a switchblade and cut the rest of the bothersome suit off, revealing an imposing uncut brown cock growing into the cold night's air. She got down on her knees and traveled south to study it better. He tried to scream again.

Dex shoved the muzzle of her .45 hard into his open mouth. He shut up. Terror froze his handsome face but his cock kept growing and his blood stirred in his frightened body. Shell's claws dug deeply into his right thigh as her other hand clawed up his freely hanging balls,

up the thick shaft. The dark pink head grew and emerged from the meaty folds of the foreskin. Shell grabbed the shaft tightly at the base and pulled his cock toward her mouth. Her double-pierced tongue slithered out and warmly coiled around the fleshy ridge of the head.

The pleasure of Shell's tongue shot deep into the base of his balls and Kenji's mouth slackened around the gun.

"Suck it!" barked Dex. The target of her snarl wasn't entirely clear, so Kenji wrapped his lips around her gun frantically and sucked at the same time Shell wrapped her mouth eagerly around his dick. Dex grinned and slowly began to thrust her piece back and forth in his mouth. The shaft oozed silver with warm mouth juices. She grabbed his dreads on the top of his head and rubbed the back of his head slowly up and down her crotch in time with the thrusting of the silver barrel. His eyes opened wide, feeling a large bulk swelling in Dex's torn racing pants. Aya leaned in and ate at Dex's mouth and her lover happily ate back. Shell began to swallow Kenji's cock deeper into her hungry throat, pulsing, sucking, gagging and then sucking deeper still.

A cold metallic sound whizzed by Dex's head and cracked against the wall behind Kenji's left hand. Chin stood over them with a demanding look.

"You bitches planning on sharin'?" she barked crossly. Lady Blue cackled behind her and wrung her mean little fist in anticipation.

Sharp tugging pain wrenched at his scalp as Dex dragged him to his feet by his dreads. She shoved him tottering into Lady Blue's clutches. He fell into her arms. Shocked at her strength and height, he stared into her odd eyes—one warm Japanese black eye and one of icy foreign blue. Momentarily he lost the sense of time, transfixed in the weird fascination of her gaze. Lady Blue brought him right back to the pain of the moment as her strong hands dug painfully into his biceps and she kicked his feet apart. His faced shoved into her chest, he no longer stared into her eyes. He felt the soft flesh of her breasts and breathed in a heady mixture of black leather, expensive perfume and the aroused sweat rising from warm feminine flesh. It felt good. His freed cock pressed against her long legs and throbbed. He pressed his body into her with pleasure.

Then, with a metallic crack, fire tore across his back. At least it seared like fire. Then another burning pain tore across his spine. He wailed. He heard the women laughing and the sound of the metal

Midori

K whip coming down again. The whip tore through the back of his
i body suit. Then another, and another, and another burning stroke
t ripped at his flesh. The black Kevlar gashed open and blood oozed
s from the long welt on caramel skin like some obscene pussy dripping
u blood. At the sight of blood Chin whipped even more viciously. His
n suit shredded off his back like rags as he keened like a wounded ani-
e mal into Lady Blue's breasts. She pulled her jacket aside and shoved an
erect, pierced nipple into his mouth. Chin whipped, he bit down and
G Lady Blue growled in pleasure. The cutting pain shot from his back
u through to his gut, and he screamed into her pale tits as his cock
m thrust, dripping, onto her leathers.
l Suddenly his own unmuffled screaming filled his ears as someone
yanked his face off Lady Blue. Dex's fingers clenched a wad of wire-
filled dreads. She never could stand to see a Sister hurt by others, espe-
cially by prey. She couldn't stand it, even if Lady Blue liked it that way.
Dex couldn't quite admit that she needed to be the one to hurt her
Sisters. Her jealousy burst straight into her cock. Her clit and lips tin-
gled deep as the neurosheath meshed into the blood engorged nerve
endings and the beige jelly cock swelled to full erection. She ripped at
her crotch panel and pulled out her seething, rage-aroused cock. She
shoved him past Lady Blue, who stepped aside for a better view.
Kenji's pretty face kissed the ragged brick wall hard and Dex slammed
into his back with all her force, knocking the wind out of his tattered
body. The blunt pain was a relief from the stinging burn of the whip.
The pleasure confused him. He felt his knees buckle but he couldn't
even fall under the bracing strength of Dex.

 Watching her lover commit carnage, Aya slid in behind Lady Blue,
wrapped her hands around her lean waist and slid her small hands
down Lady Blue's pants. She felt for the heat and her fingers followed
the dripping moisture. Soon she was handfucking Lady Blue, bent
over in her arms, pumping in and out of her sopping cunt as they
both fed on the vision of Kenji's ruin.

 Dex ripped off the remnants of Kenji's suit, exposing a high-rid-
ing round ass. Dex reached over to Shell and pulled her into her
embrace, never letting go of Kenji's dreads or easing up on his
shoved-in face. Dex kissed her deeply, leaving a trail of saliva flowing
down Shell's flushed lips. Shell grinned and bent down to take Dex's
thick synthcock into her greedy mouth. Dex groaned low and hot into
Kenji's ear. Shell could practically suck the nanomesh right out of the

jelly, right down to her clit. Kenji was losing his mind as his cock ached and throbbed to the sounds of slurping, dripping, and cock-sucking behind him.

Shell slathered Dex's cock with her hungry mouth, leaving it dripping like her own cunt inside her suit. Dex pulled Kenji's ass up, separated the round orbs of cheeks and admired the tight brown hole for a moment. Then she grabbed her own cock hard, pressed its wet head onto the tightly puckered hole and pushed. He clamped up in terror. She shoved one hand into the back of his neck, grating his face against the bricks, grabbed his belly with the other and then rammed herself into him, all the way to the hilt. Sharply he sucked air into an imploding scream. He was being ripped apart. Dex pulled the fat shaft out a bit and then slammed back into him again, eventually riding him in a steady, plowing rhythm.

His aching cock grated hard across the brick wall. The more the women tore at him and used him, the harder his cock raged.

The women kept laughing. Dex's fucking grew deeper and harder. Kenji's world grew black and he felt weak. Dex let out of loud groan and came hard into him. She shuddered so hard that if her cock could shoot cream he would have had come flowing out of his gaping mouth. He felt her come shoot out from his own balls and up through his cock head. He shuddered and splattered jizz onto the cold, mean wall.

His body bleeding, bruised, and broken, he lay panting in a pool of come and grease. As the world faded into blackness and consciousness slipped away from him, he heard their laughter and the roaring sound of the bikes speeding away.

Aya moaned as Dex fingered her cunt under the sticky table. Chin watched them in mild amusement as she oiled her tanto, a short war sword. Shell grinned all goofy in the visorcam, already a few drinks too many. Lady Blue was fondling the ass of the new waitress-whore at the table when she let out a low whistle, blowing the cheap cigar smoke away. "Well, well, well! Guess who's come back for a little fox hunt?" The Sisters turned to the door see Kenji, alone and unarmed, stroll into their dirty little bar again, more sheepish than regal. His package swelled a bit too obviously under a new Kevlar body suit.

A CAT NAMED MIU

Only three doses remained in the gun cartridge. She knew that much without looking anymore. In the past few hours she had looked into her satchel enough times to know. Nothing ever changed, but she kept looking anyway. Hoping somehow that either more dough or dope would just magically materialize in there. But each time it was the same. Nothing ever changed. It was just as bad as waking up each morning.

One dose delivery gun.

Three full ampoules of the purest high she could buy, loaded into the gun.

A handful of empties for hoped-for refills.

And a cheap can of synthetic cat food.

Then there was the old black mink fur blanket—bedraggled, warn, faded of its old glory, but still soft to the touch... Like her. Unusual that it was made of the real thing, a fully organic, natural animal... Not like her.

She sat on the back stoop, which served as the main entrance to the unauthorized brothel she reluctantly called home. Home, if she could get a trick to pay for her and the room for the whole night. Otherwise, anywhere she could hide and make a nest with the blanket served as her home.

Snow fell softly in the filthy alleyway and onto her hunched shoulders, covering the sins and the wretchedness of the Meat District. A dusting of snow haloed the loose-flowing orange hair, about the only brightness in the hazy dusk of the alleyway. Some of the old warehouses in the District still churned out vat-grown protomeats but

Midori

A Cat Named Miu

most of the concrete buildings now served as squatter colonies, shooting galleries, and illegal brothels. Over the last few years it had begun to snow in ShinEdo. Something new for all the dregs stuck here. Politikos and do-gooders on the ether squawked about some Kyoto accord or Melbourne treaty and something about global warming. It never made much sense to Miu. Warming? What's this got to do with warming? All she knew was it was stinkin' cold and she couldn't stop shaking.

Brushing the snow off her black thigh boots and shaking her freezing tits into shape, she looked down the alley. No johns or tinted-window flesh broker cars, just some other ho's and dopers. But then again, there were no patrols either. She decided to stay out a little longer, hoping for a trick. She got one last night, so she's gotta keep trying. The blanket will stay in the satchel for now, so she can show her lean and leggy body off a bit longer.

She hated squatting in the District, but at least she was free. At least that was what she kept telling herself. The bitter truth was that at that very moment she wished for her old life as a captive back.

Reaching into the bag, her painted claws clicked metallic against the dope gun. Long pale fingers wrapped around automatically and caressed its hard contours. A familiar motion on familiar lines, comforting like caressing a lover's skin in the darkness. Arousing as stroking a lover's cock in the black night. Exhilarating as feeling the hard certainty of knuckles on cheek.

Hunching over deeply on the steps, dropping her head between her knees, she shielded the gun from sight. She caressed the magazine loaded with the three precious doses. She always loved to love the gun before shooting up. She liked to make the moment last as long as she could. The doses gave her the high as good as it could, but the gun made it different. It was like a lover's cock or tongue. Where the gun punched the dose in and how slow or fast the trigger was pulled seems to make the high different. Shooting up quick in the arm was as cold and rushed as a paid fuck from a john. She didn't much care for that. She liked to let the gun fondle her.

When she has a room of her own, she spends hours playing with the gun. Lying back she grips the handle lightly, feeling the cool, uncaring steel and smooth, indifferent plastic. It does not care. It does not

want to destroy her. It does not want to possess her. She can love it
freely for its indifference. The muzzle with its perforated snub nose
presses into the back of her knee. That's an easy spot, but that's where
the weekend partiers from the burbs like to load up. Purely amateur.
She lets the muzzle trail up her delicate inner thigh, where the downy
faint fur of sparkling gold delights so many visitors. The gun moves
up the thigh, slowly teasing. It avoids her cunt. Save the good stuff for
later. Laying the gun down flat against her belly, she feels its weight,
surprising for its modest size, bearing down just above her uterus. The
compressed gas canister gives it a satisfying load. Shooting up into her
belly always makes her break into a fit of mad laughter. She doesn't
know why, but somehow she always ends up sobbing after the mad
cackles.

Then the gun trails over her hip and presses into the base of her
spine.

This is where the high rollers install a port for the drip injection
model. Slow and warm with each drip, she's been told. Not a ride she
can afford. The jack install is solely for the leisure class. But she's
loaded plenty of drip jacks for owners and renters in her past. Pin the
tail on the rich man. She wonders what it would be like to unload a
clip with a gun directly into her own spine.

The gun wanders up to her small, firm tits. It presses eagerly into
the pliable flesh like a hungry child insisting on a feeding. She likes
shooting up into her tits. One in each tit. The fatty tissue holds it for
longer and feeds the rest of the body at a nice slow pace. It's a cheap
substitute for the spinal jack, one that scars. She likes the way that the
injection swelling makes her tits bigger and more sensitive. The pain
hurts sweeter and that makes her wet.

It moves up a few inches and the muzzle stills just above her heart.
One shot there and it's bye-bye. Serious as a heart attack, as they used
to say. She took out her second owner like that. He was such an
ancient cretin, and she was so young, that the medicos just figured it
was the real thing. Then, she was sold again. The gun kisses its way up
her long pale neck, past the blue vein throbbing in anticipation. The
gun rests on her plump red lower lip. A wet tongue flickers out to
brush its thick head and curls around its ridge. The faint taste of sour
dope residue tingles. Her heart races. She parts her lips to let the muz-
zle slide into the hollow of the mouth. One long mouth-inhale and
she can taste-smell the rank nitrous and sulfur. The teasing taste alone,

Midori

A Cat Named Miu

full of the promise of orgasmic oblivion, makes her swoon. The gun shoves deeper into her mouth, eager and thick. Gulping, she lets it go deeper. Her tongue pulses and wraps around the metal and plastic shaft in autonomic waves, trying to suck the sweet dope out of its unsurrendering core.

Not yet, too soon. She can't feed in her throat. It would shoot straight into her brain and her blood, sending her into an unending oblivion and then the cold abyss of the Jane Doe morgue. Tamako, her littermate, went like that one day. After the last rape... She knew it would be easier, warmer and nicer after the shot. Miu would go that way someday, but for now, she was too chicken-shit. Her throat and mouth goes dry at the thought, letting the muzzle drop out of her mouth. A thin trail of bitter saliva trails out, clinging to the gun and oozing down her chin. Lipstick marks cling to the barrel.

Clenching her eyes, she shakes away the memory of Tamako's unseeing eyes of the living dead and faint frozen smile, staring up at her from the bottom of the cold washroom floor, from her broken little calico body and shattered head. Shaking the gaze from the ghost eyes, she forces the gun down between her thighs. She needs the certainty of the high now, not the fear of the past that will come again for her.

She shoves the gun between her thighs. And the gun moves, seemingly on its own, knowing a familiar place. The head, now warm and wet from her mouth, tickles the soft ginger yellow fur of her thick outer pussy lips. "Puusssey" lips, she likes to pronounce it, because she likes the way it sounds. A pussy, with a pricey pussy, so she likes to think of herself. The length of the shaft slices between the outer lips and petal-like inner lips. The inner lips swell and dew forms, dripping from the bottom of her gash like the poison honey of a rare flesh-eating orchid. The muzzle dips into this viscous stream of fluid and begins to circle it around her opening. Her clit swells, the pussy lips swell and a tongue darts out to lick her painted mouth. Panting faster and faster, she struggles at the edge of the overwhelming desire to impale herself onto the gun and the urge to hold the pleasure and its certain end off longer. She pushes and pulls away, the gun still at her gash. The gun, blind and uncaring of its object of conquest, its devotee, thrusts coldly forward. She gasps, opens, and lets her pelvis curl up uncontrollably, swallowing the shaft as deeply as possible, until the handle grip digs too painfully into her swollen clit. Easing back, she

returns to a slow rocking motion with her hips, swallowing and
pushing out the gun at a hypnotic pace.

 In and out
 Deep and shallow
 Forward and back
 In and out
 Deep and shallow
 Forward and back
 In and out
 Deep and shallow
 Forward and back

 Detached from her own hand, unaware of her pale finger's slow
squeeze on the trigger, she feels the snub muzzle press into the urgent
swelling inside her, that spot inside, just along the forward wall of the
pussy muscles. The urgency fills her with a desperate need to explode.

 The trigger drops. The hammer releases the spring-loaded dope
down the self-sterilized inner shaft. The gas punches the atomized
dope into her G-spot. Her mind and flesh melts white-hot. Gushing
gallons, she flushes the gun and the bloody residue out.

 Limp, she can lie there for hours with her faithful lover-god-
destroyer beside her—still uncaring.

Today she had no such luxury of a room of her own. Dropping her
head between her knees, she shielded the gun from sight and quick-
ly popped a dose ampoule into the chamber. Her left claw tore a hole
in the fishnet at the base of her inner left thigh. A quick kiss on the
muzzle, a lick to taste the residue, then she pressed it into the pale,
cold skin under the fishnet. Without ceremony, eyes clenched, she
pulled the trigger. A bitter sting made her shudder and clench her
teeth. Tiny pearls of blood floated onto the surface of her thigh and
clotted in her ginger-colored fur. An acid taste filled her mouth as
stomach bile recoiled upward. It was just not as sweet as it ought to
be, but it would do in this crappy situation. She stashed the gun away
and leaned back on the snowy steps, throwing her legs out carelessly.
The warmth started to spread from the shot and she floated just above
the steps. The empty cartridge clanked on the sidewalk.

 As she lay back on the steps the snow fell steadily, gently laying a
crystalline veil upon her.

 The warmth in her limbs felt like summer sunshine. Her mind

37

Midori

A Cat Named Miu

continued to float up. She soaked in the warmth of the sun with each layering snowflake. It had been too many years since she last enjoyed the unobstructed heat of summer sun on her skin. She had sun back in the Kennels. At least there were some trees back there too, but there were also high, barbed-wire walls surrounding them. She leaned back on the trunk of the massive oak tree, lay down on the patch of deep green grass and closed her pale yellow eyes. Beyond the laughter and screeching of the other children she could hear the faint, soothing song of leaves rustling in the wind from the woods beyond the heavily guarded kennel grounds.

The kennel yard was usually too crowded to find any space alone but it was better than the cells inside. They were little environmentally controlled crates with nests, one stacked upon the other, row after row. The teener cribs were only stacked two high and were larger but the infants were plugged into incubator style cribs stacked many high. Usually the older ones had more spacious cribs but they were also more heavily enforced, just in case their meds, hormones, training or just plain desperation berserked them out. Every night she'd hear someone screaming, followed by sound of running guards and night orderlies in heavy boots. The screaming and battering would go for a while and then frightful silence. She'd bury her head in the sponge-like nest material to escape the sounds. She'd bite her own flesh so she could lose herself in her own pain. Each night she looked forward to being bought out of there.

She opened her eyes and saw Tamako leaning over her. Smiling broad and warm, she showed her too-sharp teeth. The scar above her lips showed clearly in the afternoon light. It never quite healed clean after they finally sewed her cleft palate and lips together. Green and brown, her unmatched eyes pointed up too steeply at the ends. They twinkled with inquisitive playfulness. Miu couldn't decide if Tamako looked beautiful as a whole with odd looking parts or had beautiful parts but was unsettlingly strange and feline as a whole. Tamako leaned over and kissed Miu full on the mouth. Pink tongues darted out and greeted in moist entanglement. Miu liked the feel of Tamako's scar on her tongue and lips. Best of all she liked what Tamako's tongue did for her clit, for sweet hours and hours after lights-out in the kennel house. The sharp teeth would bite into cunt lips, making Miu growl. With Tamako, she learned that pain was sweet. Tamako's purring always made Miu shudder. Tamako would always drink up

every bit of pussy juice like a greedy kitten with a warm bowl of milk. Sometimes her raspy tongue would make Miu bleed. With Tamako, she learned that she needed the pain. Then the two of them would stifle giggles and swap places. This afternoon, Tamako pressed her small sun-warmed body against Miu. Miu lazily accepted her brood-mate's tender caresses and body heat. She just wanted to fall asleep with all the warmth of the sun and Tamako's arms around her.

Until she was sold, she knew nothing but life in the kennel. Even though they had no experience of the Outside World, the children developed their own channels of communication and information gathering—of the world and of their own genesis. Rumors, loose - lipped orderlies, careless doctors, stolen documents and gossips fed their curious minds with information that their Mom Boxes would not provide. Each year the facility became more crowded. The lab and kennel did a good business with the increasing black-market demand for customized, unregistered and altered flesh. Located inland on the southern part of mountainous Shikoku Island, no one suspected the old orphanage to be anything but that. More likely, no one cared a hill of beans about what happened behind the secured compound gates in that sparsely populated and economically depressed area.

Her legs began to tingle. Her bones felt chilled to the core. Where had Tamako gone? Was it feeding time? She reached out with her right hand searching for Tamako's comforts. Cold fingers groped dirty snow. The green grasses gone, leaving only icy concrete against her stiffening back.

The cold was no good for the high. It made her warmer, but sleepy. The dope and the cold made it hard to stay alert and work. She wondered if she had missed a trick. She wondered if Tamako was warmer now that she was dead.

Standing, she shook off the layer of snow and stomped around a bit. A car drove slowly up the alleyway. She strutted stiffly to the curbside. The visored figure, seated behind the driver, looked over, looked her over, and then over-looked her. Probably a freak collector, she figured. Miu looked too normal for those types. They liked 'em like Tamako. With all the parts put together wrong. Then they could clearly see that the pets weren't quite human. That way they didn't feel so bad in acting out their depravity on them. All of Miu's freakishness was built into her plumbing and DNA.

She returned to the stoop. She sat still for a while, holding her

Midori

A head in her hands. She was too tired to cry. Looking up to the gray heavens she saw the dingy snowflakes coming down relentlessly. A little longer, she decided, a little longer, and she'd give up. Fumbling, she wrapped the old mink around her shoulders, still showing her long legs for would-be johns. Feeling weak, her belly knotted in hunger that would not be ignored. Reluctantly she opened the last can of synthetic cat food. Using the lid as a spoon she slurped the sludge carefully. Consuming only half of the can, she saved the rest for later. Self-pity sank into her gut along with the brown sludge. The chill crept back into her legs.

She reached for the gun again. No longer bothering to hide the gun from sight, because there was no one to see it, she popped an ampoule into the chamber. Wrist heavy with resignation, she pointed the muzzle onto the same spot, right on the frozen, blood-matted fur.

Eyes clenched. Trigger pulled. Sharp sting followed by the shudder. She exhaled in a grimace and waited for the bile.

Then she waited for the warmth.

As certain as misery, the high came, fuzzy and warm, pushing away the cold and letting her float again. She closed her eyes and let her head fall back. Her legs twitched, shaking the new flakes of snow off her thighs. The fuzz of the blanket tickled her neck.

Her last owner had given her the blanket. It lined the shipping crate that arrived at the broker kennel to transport her to him. The new owner's representative ushered her with pride and care unusual for this sort of transaction. The new owner, she figured, was rolling in dough... and was obviously twisted. Only the twisted bought unregistered pets like her. The crate was warm, and she soon drifted to sleep on the long voyage, slowly rocking from side to side in the furry darkness.

Snow fell steadily on her lax limbs and the gray concrete steps.

With him, she wanted for nothing, except freedom. Her room was neither a cell nor a kennel, the usual choice of owners for creatures like her. She actually had a room, as odd as it was. She liked the large room with a domed sky window that showed the pollutant-sparkling atmosphere by day and the cyan-glowing haze of the sky by night. The residential environment was perfectly controlled for comfort, just warm enough so she never wanted to wear clothes but not so warm to be uncomfortable. Everything seemed to be covered in fur, the floor, the blobby organoform furniture and even the undulating walls.

It was all real, no synthetics, and to the best of her touch sense, all grown on moving meat, real animals, not on sheets in the lab. All of which were black market goods... like her.

All day and night she would lounge and wallow in the furs, napping under the toasty solar lamp or diving and rolling between piles of fur blankets and untrimmed skins of exotic beasts. She liked to run the long strips of silver fox tails along her cunt, making it tingle and wet until she'd come laughing. She played and lounged without awareness of time. She marked time only by his visits.

He would simply enter her room, as was his right, but he would not fuck her immediately. He would sit on one of the blobs and watch her, not jacking off, not talking, not demanding anything. At first she was self-conscious, feeling some need to perform for favors, but as time went on and he continued to do this, she simply became accustomed to his attentive and amused gaze upon her. He was a smallish man of indeterminate age. His jet-black hair was full and lustrous, marked with a few wisps of white at the temples. For his size and full Japanese blood, he was unusually muscular, with well-developed pecs and rippling back muscles chiseled under dark skin. He was obviously a vain man, as he kept fastidiously hairless below the neck. All this served to enhance and frame the magnificent scarlet carp, white-capped blue waves, and golden chrysanthemums inked into his back and pecs. The ink extended down to his wrists in intricate patterns of waterfalls, lightning bolts, and the Thunder God. Men like this were fully covered in public, even in the oppressive summer heat of ShinEdo summers. Men like this were the cruel nobility of the underworld. Yakuza.

After a long period of watching her sleep or play, he would come over and silently stroke her orange-red hair, down her back, eventually stroking her pale, round ass. She arched her back in pleasure and stretched in the fur pile to better feel his warm caresses. The gaze caressed her and his hands adored her. She knew that she would be taken, as they had all taken her, but he possessed her in ways that no other had. One strong arm would wrap around under her belly and prop her up on all fours, forcing her ass up while his other hand, square and strong, grabbed her cunt lips by the fistful.

She gasped, then moaned a low growl. He dug his fingers into the flesh of the thick outer lips and twisted. She moaned louder and pushed back onto him, ass arching up higher. He twisted even harder.

Midori

A C a t She felt the heat rise in her gut and spread to her clit. Then the juices gushed the first wave. When he hurt her, she didn't so much drip or ooze from her cunt, instead, the pain made her flow in sudden bucketloads. His palm now soaked in pussy cream, he dragged his hand across her cunt and coated his entire hand.

N a m e d He gripped her more tightly around the waist, squeezing out the air from the base of her gut. He pulled his wet hand back and formed a fist. Placing it at the dripping and swelling cunt lips, he paused for a moment. Then with one uncompromising thrust, he plunged a huge burning fireball of a fist deep into her. She screamed and tried to pull away from him, but he had her firmly trapped in his muscled arm. With a slow and relentless rhythm he fucked her. She would open up to swallow him against her own desire to flee. He fucked her into a screaming oblivion, where her mind seemed to melt away, leaving only searing pain as proof of her existence. Helpless against the building tension, she came in tsunami waves, shuddering over and over until she fell limp and warm in his supporting arm.

M i u He would dump her onto the fur, still unspeaking. He never spoke. She never learned his name, in all the years that he kept her. He never even demanded she call him silly names like "Master." He simply was, and she simply was his.

Only after exhausting her into a puddle of flesh with his fist, a fuck machine, or some other device of brutal invasion, would he really fuck her. He kept several custom-designed cock neurosheaths in a locked plexi cabinet in her room. Locked, so she couldn't hide or destroy the sheaths. Clear plexi, so she would have to look at them all the time.

Huddled in the sea of soft warm fur, she heard him snap on the device. She was too exhausted to lift her head, much less resist. Its opaque pink, jellyfish-textured skin bore into his, nano-linking to the nerve endings. He could feel her even more intensely through the amplifications than his actual dick ever could. His excitement caused the sheath to swell and the black-tipped barbs to wave menacingly.

She used to fight him as he thrust into her. When she was new to him, she would fly off his cock like a cannonball to flee the agony. After a few rounds of such recoiling behavior, he began to exhaust her before his entry with brutal multiple orgasms. Now it was a regular occurrence.

Once again he snapped the sheath onto his cock, as she lay there,

powerless, with waves of orgasms still washing over her. He wrapped his fingers tightly into her hair as he entered her from behind. His thick cock made painfully thicker from the sheath, she moaned in resigned pleasure. The barbs were not up yet; the entry was smooth. He thrust in and held himself still in her wetness. Without any warning, he pulled her head back and aside and cracked the other hand, flat palmed and hot, across her exposed cheek. She shrieked. Her cunt clenched. His dick throbbed. The back-curved barbs popped up and dug into her pulsing cunt walls. She yowled and arched her back in the searing pain. She tried to pull away and the wicked thorns dug deeper into her pussy meat. Her breathing quick and shallow, she tried to swallow the pain, but it wouldn't go away. It hurt.

He began to thrust in a slow and steady motion, each stroke nice and long down her cunt shaft. With each in-stroke the barbs would lay down smooth and she could breathe without pain again. With each out-stroke, they dug in deeper and tore at her. She would try to reach back and lash out at him but he controlled her with ease using her hair. Only when he drove his cock further into her could she feel relief and comfort. Soon she felt the heat, as the sheath and his cock savaged her, she felt warmth spread over her. The steady pain and relief made her howl in agony and joy. Bucking and clawing at the air she sank under the waves of shuddering, unending climax until he came into her with a massive final thrust.

She rolled over, seeking his strong hand, warm caresses and wordless love. In his own way, he loved her. In his own way, he was merciful.

He just couldn't understand that setting her free was no mercy. It plunged her into a lonely, frozen hell. She no longer belonged.

She felt the ice-cold concrete under her snow-encrusted cheek. She felt sick from the bottom of her empty gut. The snow was thicker on her legs now and she couldn't feel them much any more. Wrapping the fur tightly around her shoulders, she felt brittle and cracked.

The fur blanket was all that remained of him.

The snow fell steadily onto her hunched shoulders, covering the misery of the Meat District, burying her and her memories.

Once again she reached for the dope gun, now fallen on the step below her. Fingers stiff from the cold didn't feel like her own. She

Midori

A watched her own hand fumble to load the final dose.

C
a
t

The heavy gun trembled. Grasping with both hands she steadied it as best as she could. She realized that her hands trembled. She heaved the gun up to her thigh. Stopped. The trembling stopped. She brought the gun up further. The gun rested on her bluing, cold lower lip. She parted her lips to let the muzzle slide into the hollow of her mouth. One gulp and the gun thrust further down to the back of her throat. She felt the muzzle press against the soft flesh just below her brain.

N
a
m
e
d

Eyes clenched. Trigger pulled. Sharp sting followed by a shudder.

This time there was no exhale.

Then she waited for the warmth.

M
i
u

MANTRA

The inky heavens gradually turned a mournful shade of polluted gray, signaling the end of the First Morning Prayers to the Blessed Light of Serene Life. The colorlessness of the weeping sky crept into the vast prayer hall through the diamanoid roof and nouvelle Tibetan spires, forming no rainbows of dancing lights. Ranshin turned her glassy-eyed gaze from heaven to the writhing bodies around her and back to heaven again. She closed her eyes and inhaled deeply the out-breaths of the faithful. She stilled her lungs from any motion and let their breaths sink deeply into her fibers. She opened every millimeter of her skin to feel the totality and singularity of their touch. Hands and mouths swarmed over her flesh. The squirming mass of body parts engulfed her like an army of ants over a fallen plum, split to the core and oozing red pulp.

The moist floor undulated beneath her.

She exhaled from the core of her soul. The hands and mouths melted into her flesh and she dissolved. Her soul exhaled to a bright white and she convulsed. She convulsed for half an eternity and the hands and mouths flowed through her. The Big Bang subsided and the hands and mouths, like stars born from her, slid and sped far, far away.

She did not feel them come, gushing all over her. She did not feel the floor convulse beneath her. She wasn't there to feel the body fluids and contractions of the faithful, men and women marked with jade bindis searching for transcendence in a blinding orgasm. Instead, her essence was somewhere in the core of the womb of the All.

Someone laid lightly the pale green gossamer veil of polygold over her limp body. Another placed a half-blossomed synth-lotus, creamy

Midori

white and tipped in crimson, upon her breast. Then another blossom, and another blossom and another... until her form disappeared under a cascading mound of fragrant petals.

The faithful retreated backwards in half-bows, hands pressed together before their faces, careful to not show their backsides to her in this sacred moment. As the tide of flesh ebbed away from the pyre of lotus blossoms, a drop of purified water fell from the highest point of the spires, hit a quivering petal and fractured into a thousand little water droplets. Before those droplets could settle upon other petals, the ceiling had already begun to deluge her with the soft interri-rain.

She was sated. For a brief moment, she existed only for herself.

The floor continued to undulate gently beneath her, sucking up the rain, sweat, and come. Constantly growing and living, the soft pink carpet of vaginal flesh resonated and moved to her pleasure. After all, she was its genemother.

The gentle light effects of sparkling pink and amber created the ethereal sunrise, never actually seen in ShinEdo. It pulsed at a subconscious trigger rate designed to inspire awe and suggestibility. It was all designed by the geniuses in the Apostles of the Open Hand for All department, a.k.a. Marketing, just a few floors beneath her spent body.

Kyosan Utamaro Ranshin Zuikoh Daiyon, formerly Sasaki Yuriko, waited perfectly still for the murmurs of voices to pass and the rain to recede with the retracting nozzles. She raised her head slowly, shaking off the flowers and veil and sat up on her elbows, body akimbo and head thrown back lazily. In a few moments the drone would enter to clear away the debris of the morning meditation. Until then, all was quiet and belonged to her in these precious moments.

She let her delicate fingers linger over the curve of her hip and into the hollow formed by the hipbone and pelvic mound. In returning to the warm flesh pleasures of her own body, she returned from the cosmic dissipation. Her fingers roamed over the smooth, hairless pubic mound. Flushed lips fell back in a slack smile of pleasure. The Vessel of others' desires might burst from fulfilling her duties, if she did not seek constant humility in her human limitations and awareness of the solitary pain of pleasure. Saffron-dyed nails roamed down further. Her breath quickened slightly and her cheeks flushed. Folds unfolded and fingers danced around her rose-colored pearl clitoris, eliciting contented sighs. Then the index finger, wandering further down, felt the first scarred incision and halted. Her brows knitted, the

smile faded to a tight little downturn and the orgiastic flush faded to pallor. A necessary and jarring ritual, this touch always returned her fully from the orbit of pleasure to the earthly bounds of clerical duties. She let her digits roam freely over the stitches. With each prayer-gathering she would forget her own mark of renunciation. Then, after each prayer she would be reminded of them, as her own vaginal contractions found no flesh to grasp upon.

Following the faith of her parents, she had entered the monastic life and clerical training one full solar year after her first menses. She knew she was ready. She studied, attended to her parents at the orgiastic prayers, yet kept her flesh untouched by pleasure and waited to surrender her orgasms in search of Clarity and in service to humankind. She endured two more solar year cycles in an arduous initiation, then made her final renunciation and was accepted into the Order. On the day of the final renunciation they shaved her head and sewed her inner labia shut. She renounced her right to pleasure of her own cunt. Sacrificing this, she would learn every possible secret to pleasures of the flesh as path to release of the soul.

The incisions scarred, but the sutures looked fresh as the day of her renunciation. Each day she and all others ordained contemplated their threads. An Ama could remove the stitches at will and cast away the Teachings to shun the Order. In turn they would be cast away from the Temple and the path of seeking, to walk the world alone. In her daily Reconsideration, her faith was clear. But of late, some weariness weighed heavy in her steps.

She prayed even more.

In her antechamber, she had barely finished donning the saffron gold veil of spider silk, when the holo wall chimed. She accepted the call as she did each and every morning.

"Blessed is the Pleasure, my Revered Elder Sister," said the staticky form, quickly forming into a woman-shaped bulge on the pale bamboo wall.

"Blessed is the Pleasure, my Little Sister," replied Ranshin, turning her right palm heavenward and her left to her womb. The bulge bowed, seeming to nearly fall out of the wall. It wore a deep purple veil, fashioned much like Ranshin's, but lacking the jewels and gold-threaded embellishment of Ranshin's rank. The digital bulge belonged to Anandya Shaktidas Kevala Kailasa Deva-dasi—the fiercest guard dog in the form of feminine beauty to ever serve any Ama. Kevala now

Midori

ranked high enough as an Ama herself to preside over any of the sub-parishes, yet she chose, after 15 years at Ranshin's feet, to continue as an attendant. For which Ranshin was grateful.

They dispensed with the shortened form of the sacred greeting rituals as is the right of the highest Ama, and moved on to the mundane matters at hand. Prayers, blessings, meetings and a public appearance filled her agenda. As they chatted, a jeweled drone floated past Ranshin like a willful jellyfish, towards the fleshy meditation hall to clean the debris.

Later, the fluids and flowers collected by the drone would be distilled, combined with various temple-raised herbs, some of them engineered for subtle hallucinogenic effects. This was an ongoing operation, somewhere in the bowels of the tower beneath them, as the resultant Essence was considered stable for only 24 hours. Younger Amas in various parishes customized the Sacred Essence for each bliss seeker in accordance with Vedic diagnosis. The poorest of the suppli-cants received a few drops in a simple vial emblazoned with the Order's seal. The most generous of the supplicants not only were allowed to attend the prayers that made the Essence, but built private prayer chambers in their own homes, continually filled with luxuri-ously expensive Essence steam. It was said that partaking of the Essence would connect the supplicant with the ecstasy and clarity of the prayers, restore calm, and combat the health and beauty ravages caused the environment better than any retro-gene therapy on the market. It brought vast daily tributes to the Order, thus the Apostles of the Open Hand for All were pleased.

Ranshin remembered when the elderly Korean Ama, Gim-sama, distilled and prescribed the Essence to each disciple in her desolate mountain retreat. The copper kettles constantly boiled with strange plants and fluids from the prayers, as glass tubes and flasks whistled with steam like an old train. Ancient herbs hung from the rafters and the tangy, musty smell clung to everything. It was just before Ranshin's seventh lunar birth year, and Gim-sama seemed to have taken a liking to the bright little Yuriko. She was allowed to play in the Dispensary, watch and even help Gim-sama. The Ama even allowed Yuriko to address her in the familiar "Obahchan"—or Granny. Amas with their renounced and sewn cunts never bore their own children, so it was common for the older Amas to take a liking to the little ones. Eventually the higher-ranking Amas would take in a few of these

youngsters, the promising girl children, as apprentices. Playing at Gim-sama's side, Yuriko did not notice that her young, wealthy, and idealistic parents no longer had time for her between their prayers and sensual studies. Back then, Gim-sama brewed the Essence by hand and granted it only to the pilgrims in that remote temple.

Much has changed since then.

A gentle chime resonated in her chambers and the waterfall on the south wall parted to let her palanquin of indigo cushions and saffron curtains float in, followed by Kevala's deeply bowed, purple veiled form. The shimmering gauze draped over her voluptuous naked curves. They murmured the words of sacred greetings as Kevala gracefully sank to the floor to lie prostrate before Ranshin. The purple veil floated briefly, as if still shrouding a body no longer there-and then sank softly next to the devoted naked attendant. Her oiled skin shone supple and dark under the warm chamber lights. Ranshin always took pleasure in Kevala's kowtow, a bow as soft as a butterfly alighting upon a lotus blossom.

Kevala's jeweled forehead rested upon Ranshin's henna-inked bare feet. Snakes of long black hair coiled around the painted feet. After a few deep mutual breaths, the younger woman pressed her full crimson lips on Ranshin's toes. Ranshin closed her eyes and let her heart sink into her feet and down to the earth, some several hundred stories beneath her. Velvet soft lips parted and hot, moist breath caressed her toes. Shivers shot up Ranshin's spine. With long, thick strokes Kevala tongue-painted her teacher's feet with deep devotion. Sparks flew out the top of Ranshin's head. The copper skinned serpentess undulated on the floor, driving her pelvis slowly, rhythmically into the floor. Kevala kissed and licked feverishly, pressing her hands and face harder into Ranshin's feet and ankles. Ranshin's skin dissolved to let the devout tongue slide under her skin. She absorbed Kevala's breath into her veins and pulled her into her blood and flowed her into herself, drawing up with quickening breath to her now pulsing womb. Ranshin accepted Kevala's love into her cunt with a tight in-breath-and with a single long out-breath flowed over both of them.

Milky nectar flowed down quivering pale legs and melted into the jet-black hair wrapped around her ankles. After a moment, Ranshin opened her eyes heavily and stepped back—slowly and unwillingly stepped back.

After all, there were duties to be done today.

49

Midori

The palanquin had hovered quietly nearby. Kevala got to her knees, donned her veil and gracefully lowered herself onto all fours next to it. Ranshin nodded, stepped up onto Kevala's back and slid into it, lounging back to a graceful side prayer position atop the many pillows.

Kevala mounted her own palanquin, smaller and simpler than Ranshin's but still resplendent in the purple flowing curtains accorded her rank. With a few simple commands from Kevala, her chair hovered ahead of Ranshin's and they floated out the parted waterfall into the communal halls of the monastery. The liquid curtains closed to a forceful waterfall once again, sealing the holy dwelling behind it. Several other vehicles silently joined the procession as they drifted down the hollow core of the tower. Some transports carried the heavily armed sentries, hidden on gold plated and bejeweled hover tanks, others were simple open ped transporters of staffers, and others still were various luxury sedans for the pilgrims staying in the tower.

Thus they moved toward her seasonal public blessings, massing into a larger, glittering flotilla as they passed each level of the tower.

First was the fortified commune of the Apostles of Open Hand for All. They drifted by the schools of the novice Amas, full of girlish giggles. They drifted past the new Wisdom House of Revered Elders—the ward where aged pilgrims spent their children's inheritance on the way to their final nirvana through sexual bliss, brought to them by the skills and teachings of the Order. Somehow this new clerical duty for the Order never sat right for Ranshin. She would certainly be arguing this again with the Apostles, soon.

The middle section of the tower contained the breathtaking Hanging Gardens. A multitude of enormous white hammocks, each twice the size of sun sails, hung in shimmering layers by silver cables. Brilliant flowers and foliage spilled over their edges, roots and branches, some heavy with fruit hung from the underside, having worked their way through the loose mesh. Some gardens were full of herbs, both ancient and engineered. Thick, twisted and rough vines, some covered in lush moss draped down in curtains, connecting the hammocks as verdant arteries and veins. Yellow and blue butterflies danced in the air. Leaves and pale petals floated down gently. The rich oxygenated air somehow felt thicker. The floral perfume mixed with the heady scent of sex and sweat. Each hammock rocked and quivered as dozens of bodies intertwined in worship among the vegetation.

Hundreds of pleasure-radiating pilgrims meditated together at any given moment. The chamber was filled with sounds, many-tongued murmurs and chants barely audible, yet it filled one's chest with a sudden heat and expansive tightness, and an unnamed urgent need. This was the Music of the Spheres, carefully resynthesized in real-time from the moans of the pilgrims, ancient sutras, drumming, heartbeats and subaudible wave codes.

Ranshin breathed a sigh, almost of relief, as they passed beyond the lush Gardens.

The flotilla of crafts sank further down the core of the building, a maze of lesser halls, schools and dwelling chambers. Then they came to where the core split open to either side, fanning out to a magnificent mother-of-pearl and quartz-encrusted hallway leading to the grandly arched, red lacquered gates. Silently, reverently, they proceeded out the grand gates, leaving the gaping central core to sink further below, disappearing into subterranean blackness.

The moment the exterior gates opened to the foul air of ShinEdo, the cacophony of the swelling, clanging, heroic march-anthem of ancient Anuradhapura erupted from the crafts on the forward and flanking edges, and crimson banners unfurled above them. The grandiose procession floated well above the squalor that passed for life between the heaven-piercing towers.

The palanquin shielded Ranshin from all the grotesqueness beyond the Order. The gossamer curtains, as well as her veils, were made of bullet-proof arachno silk, embedded with the latest filters for radiation and airborne toxins, temperature and humidity regulators, and came loaded with comtech and wellbeing monitors of all forms. The Sacred Artisan Guild of the Order developed and patented some of the best personal security and wellness technology available. Those with something to lose, and those with an image to sustain, coveted and paid sweet sums for the latest technology released by the Artisans. Once upon the past, the Artisans crafted tatamis for the temple halls, prayer lingams, and toys for the children of the Order, given in exchange for simple offerings. Today, even the zaibatsu considered them a threat to their profit margins.

Safely sequestered in the delicate vessel and surrounded by the courtiers, Ranshin relaxed and prepared for the blessings as her caravan flowed between the great towers.

From the corner of her eye she saw a dark shape falling. Falling fast.

Midori

She spoke out to the curtains and Kevala's gentle voice replied. It was nothing. Just another suicide—just another tower res who'd had enough.

Ranshin sank. The prayers were not enough.

The great Arena, a modest dome from a distance, grew huge as the caravan slowed in their descent. Its massive silver dome opened—a Cyclops waking from deep slumber to glare hatefully at the smog-smeared sun.

The usual paraphernalia of sports had been cleared away for the sacred occasion, all the blood stains washed away. Soon the grounds would be filled with moaning, writhing and cheering of a different sort. The masses cheering the bloodbaths did not know who the real owners of the Leagues were, nor did most who worshipped in the Dome each seasonal mass gathering.

The Blessings began as Ranshin descended upon the central platform. She disrobed. The individual faithful melted into a flesh-colored field of writhing pleasure. The shadow of the falling man writhed around Ranshin.

For once, her essence did not travel to somewhere in the core of the womb of the All.

Ranshin self-induced and entered a long, dark sexsomnic state-customary for the high holy festivals.

Bolting upright, she woke with a start from the warm Blessings-darkness to the solitary darkness inside her hovering palanquin as the caravan made its slow journey back to the monastery.

Turning on the windows she looked onto the streets. Not something she ever did. Kevala chimed in, concerned. Ranshin waved her away. Beneath, the first snow began to dust the ramshackle markets in a delicate glitter—pretty. Zooming in and out, she looked at the faces in the alleys. An old woman hawked steaming proto-meat from a drum. A child ran by laughing. A wheezing security officer ran after her, firing a pistol. A man and woman entwined and writhed in a doorway. He stepped away and her bloody body slumped down. A red-headed woman sat on a stoop, her naked legs covered in snow.

Ranshin turned off the window and sank into the pillows.

Later that night she donned her old blue veil of a mae ji, or a novice, mounted a low-ranking ped craft and slipped out to the common halls. The interior of the monastery arcology glowed in a faint blue of the artificial moonlight. Only those closest to her knew of this

occasional habit. She floated down to the garden and found the water flower hammock. She dispatched the ped craft and stepped onto the silky white garden path. Dozens of soft glowing man-sized bubble ponds flanked the paths. Green plate-shaped leaves and delicate fragrant lotus blossoms floated on each pond's curving surface. Ranshin avoided the paths with coupling pilgrims and kept to herself in the silvery shadows.

On one such lonely path she came upon a man with brightly colored hair of red and yellow. He sat cross-legged, staring intently at the pond just before him. He did not wear the veil or bindi of the Order. Instead he wore a simple brown set of worker coveralls. Expensive hair and humble threads. Curiosity broke Ranshin's pensiveness and she stepped toward him.

"Please stop. Don't come closer," he said gently. He did not turn to look at her. Ranshin stopped, stunned, not accustomed to such rejections.

"You'll frighten them. I don't want you to get bitten," he said reassuringly. Ranshin turned her gaze towards the object of his attention. Just under the surface of the opaque bubble pond she saw a dozen tiny flickers. He signaled her to move slowly closer. Just beneath the surface of the glowing orbs she saw spiders, small, silver-sheened brown spiders swam frantically around one spot.

"They're part of my team, these water spiders," he said, finally turning to look directly at her face. Again, not something she was accustomed to, but then she remembered that she was dressed as a mae ji and he was not of the faith. He smiled broadly. She relaxed and sat down unceremoniously on the path next to the smiling outsider. Unprompted, he explained his work. "Officially I'm an arachnotech. But I prefer to think of myself as a weaver. My team—my spiders, that is—and I do a lot of the repairs around here."

"Don't we have drones and machines that do that?" asked Ranshin, her schoolgirl curiosity returning to her.

"Machines do the major jobs. They make these hammocks and even the common veils and lower habits. But these ponds need special attention. The lotus roots constantly tear at my work. And the fine repairs to the hammocks, that's our job. Pussy juice can be pretty caustic, even on web silk." He giggled like a girl. His hands moved quickly and delicately like a young woman's. "I also hand-weave the special veils, like the ones you wear for your morning meditations."

Midori

"But I don't…" Ranshin tried to lie that she was too novice for morning meditations, but the stranger waved away her unformed words.

"Your Holiness, I know who you are." He said, smiled and waited.

"But how?" she stammered.

Shaking his head, he explained "I see you out here at night from time to time. I leave you because I know you need your time alone." She started to stand up and he waved at her to stay. "Relax. I don't want to pray with you or on you or in you or anything. But I'm happy to show you my team's work if you care to see?"

She stayed.

He smiled. "My name is Jon Chin."

He explained all of his team's work. She was fascinated. She sat on her haunches as she used to in Gim-sama's dispensary. They spoke of this and that for a long time.

In a careless gesture she brushed his arm and then caught the scent of his skin on her fingers. She stared at her hand and then at him. He smiled. "So it's true that Amas have a keen sense of smell. What do you know about me now?"

"Are you a Khusra?"

"That's such a great word! I so prefer that over hermaphrodite." Jon said approvingly. "Yes, I am."

Ranshin stumbled to her feet, stepped back, and fell to her knees. She scrambled down to a kowtow. Jon crawled over to her and raised her by her trembling shoulders and spoke softly. "Please don't bow at me. I'm just a weaver."

Ranshin shook her head. "But You must be honored. You must teach us," she stammered. "Your potential for the Bliss."

"Don't be silly, your Holiness." He sighed heavily. "Don't honor me for some imagined gift. I was just born this way. Thank goodness I don't have to hide anymore. But if you'd compliment me for my weaving by wearing my veils, that would make me happy."

Ranshin grasped at Jon's hands on her shoulders. She nuzzled at them devoutly. She glanced up shyly and pleaded. "If You would only join us in our meditations, You would bring such joy to the world. You'd do such greatness in the sea of suffering." Ranshin was near tears.

Jon wrapped an arm around her gently. "Your Holiness, meditation and sexual bliss are what you do. It's what the Order does. It must

54

do some good inside the monastery here, but in all honesty, it's not making much of a difference in the world."

Ranshin froze in his arms. The shadow of the falling man flitted through her mind. The shadow grew and her mind became black.

She did not clearly recall her journey back to her chambers in Jon's slender arms. She sensed panic around her and Kevala's voice raised and tense. Then it was quiet. She slept deeply in a black sleep. She swam among the lotus roots and then sank deeper. She was falling. She was falling in an endless gray sky. Then she sat in the snow and saw faces. Saw the faces really for the first time.

As the deep gong sounded through the tower for the First Morning Prayers to the Blessed Light of Serene Life, Ranshin had not yet left her private chambers. She ignored the calls and refused pleadings from the staff or the wellness monks. Nude, she sat up on her sleeping mat with her legs spread. In her left hand she pulled at the sutures. Her right hand held the surgical cutters.

She uttered a mantra before the first cut.

THE NURSE

Even an old creep like him didn't deserve to be treated like this, she thought, especially not by his own kin. How easily she dismissed her own countless cruelties against him. With perverse delight she believed that he got off on how she treated him. At least, she continued musing, she never wished him dead, like they did.

Then she remembered she had, and often at that, so she promptly shut off that train of thought.

Rain streaked the tall, narrow windows in her room. The city lights and the silhouettes of the towers melted in the streaks. Her face stared back at her, painted in melting city lights.

Her employment with the Taira family began two years ago through a broker. She'd done this sort of job before, but never for this long, and never entrenched into a family. Usually it was just for a night's entertainment, or maybe a week's vacation for some rich bastard. On a rare occasion she got subcontractor work from a detective agency specializing in domestic nastiness. The agencies had never given her the really sweet paying jobs though. She didn't have the qualifications for those industrial espionage jobs. To them, she was simply trash from the wrong side of the res towers. You can take a girl out of ShinEdo, but...

This job was different. Other the various months and years spent in the detention centers, she'd never spent this much time in one place and she'd certainly never had a pad as cush as this. Her special job allowed her quarters better than the other staff. Some of them resented her for that, but she didn't pay much mind to them or their gossip. An enormous bed and a luxurious bathroom dominated her

Midori

The Nurse

one-bedroom apartment, fully supplied with all that she needed. Anything she didn't have was provided for her, delivered promptly by the domestics team. The pay was even better. Actually, it was astronomically good for her lot. The downside was the day-to-day boredom and continual search for activities that might amuse or shock Mr. Taira; the latter was essential for her continued employment.

Her official title was Personal Nurse to Mr. Taira Naoki, and thereby she was a special employee of the greater Taira Corporation. Unofficially, and more commonly, she was known as a grabber, a very high-priced grabber, for Old Man Taira. Like all grabbers, she came fitted with various tiny jack ports along her spine, with the largest at the base of her skull. Somewhere deep in her cortex and brainstem lived several small spider-like nanoids, embedded permanently, minding her every move. Her first set had been installed just after her final stint at a detention center. She figured anything was better than going back there for the continual bureaucratic run-arounds and bribery con games. So she sold off her experiential rights to a back-alley grabber agency, went under the knife and got the entry level ports and nanoids installed. It took several assignments with various clients to pay off the agency before she began to make any money. It felt like a scam, but at least she wasn't locked up anymore. Once she started to earn money, referral fees still took the biggest bite of the yen.

But she was willing to work a lot, and generally didn't mind her work, which consisted of a lot of elaborate masturbation, run-of-the-mill fetishes and fucking with other grabbers. Some lucrative agencies owned several buildings, made to look like ordinary res towers, housed entirely by contracted grabbers. Some specialty agencies set up fake dorms of school age girls and boys. Others even set up brothels with grabbers as the hookers and rent-boys. These agencies made double money from each fuck—one from the real-life Johns and one from the jack-in Johns. Unfortunately for the RL Johns, they were never notified that their trysts were getting grabbed and sold to others. This often created interesting scandals down the road.

She'd had a few upgrades on her system before this Taira gig, but once they signed her on for it, they gave her a complete overhaul with the bleeding-edge features, bells and whistles, not yet available to the everyday Otakus and gadget junkies in consumer land. The new installation made life more comfortable for her. She no longer suffered through blinding headaches and weird convulsions during the

downloads or any other fun side effects that came as standard features with regular units. The recruiters never told you that stuff when you signed the contract. They also never told you that the installations were irreversible and they registered you in the industry database like a piece of inventory. They said it was to protect the "service providers" from getting their hardware ripped out, spine and all, by thieves trolling to supply the burgeoning black market in grabber tech. But the grabbers knew better. They were simply components now.

A gentle bell chimed from the cart behind her. The grabber box finished the download. Soft fingers caressed her back and roamed up the curve of her back, tracing the spine. She relaxed and let the thoughts of the old man melt away. Her scalp crawled and tickled as Arisu expertly twisted the plug in her skull and pulled it out, careful to not pull any hair. Arisu was the only other person she'd let plug or unplug her. Too many technical risks plagued the download process, and anyway it was just too intimate for Kasumi.

Arisu unplugged the rest of the wires and sealed the holes with the dangling flesh flaps while Kasumi rubbed at her skull port. By the time she turned around to face the bed, Arisu was getting dressed.

"Leaving already?"

"You exhausted me!" Arisu laughed. "Anyway, there's some political fundraising party I have to attend with Erudon tonight. You know, be the dutiful little woman and all. I'll take Rachel along with me, so I'll look like the good mother as well." She shrugged.

Kasumi walked over to the bed, where Arisu snapped up her boots over the white coveralls. She pushed Arisu back onto the bed and fell naked on top of her, forcing her lips onto hers. She sucked on the plump lower lip and slid an eager tongue into the sweet cavern. She tasted her own cunt. Tongues intertwined, savoring a hint of foie gras and wine. Hands roamed lazily seeking breasts and cunts between zippers.

After a while Arisu pushed her off gently. "Don't get me started again. I'll be late!" Kasumi rolled off of her and shoved Arisu off the bed with a playful kick.

"Enjoy the enduring," Kasumi said, laughing. "I'll probably go out tonight. I need to grab some more action so I'm ahead of the Old Man's appetite." They kissed lightly, briefly, as not to get enmeshed again and she watched Arisu slip out through the back entrance.

Sighing, she sank back into the lush bed. It was a good thing she

Midori

could keep secrets. That was one of the things that kept her employed with the Old Man this long. If Arisu knew who she was meeting later that night, she'd blow a fuse. Then Kasumi would be without her favorite lover—and the Old Man would be without his favorite thrill. But then, Arisu was no innocent either.

She called Katsuo on the holo wall. She didn't bother to dress. He'd seen the goods before. The bordello-red wall seemed to bulge and buckle forming the upper half of a handsome man in sanitary-blue hospital scrubs.

"Hey Ji." He smiled. "So you want me or the Old Man now?" He always called her Ji when they weren't around the Old Man. It meant "whore" in some Chinese dialect popular with the street thugs. Of course when Old Man Taira was around it was strictly "yes, Ms. Yamane" and "No, Ms. Yamane."

"Duty calls, handsome. I got a full box to drop off. Is this a good time?" He gave her the go-ahead and faded off. So she chucked the box into its carrier and strolled into the enormous walk-in closet where she slipped on a full-length black sylk qipao. In the back of the closet she pushed a panel that opened into her private elevator. Even Arisu and Erudon didn't know about it. It gave her quick and covert access from her apartment to the Old Man's penthouse, the garage, and an alley behind the tower. The elevator operated only by palm ID authorization. Pressing her palm to the key plate she ordered it to the penthouse.

The elevator was utterly silent. But her body sensed the speed and her ears still popped.

The door opened to Mr. Taira's empty study. She stepped out and it closed behind her, leaving only a continuous wall of bookshelves. No one would detect an elevator door. She often wondered what might be hidden behind the other shelves. Katsuo came in through a proper door, from the Old Man's office, and closed it behind him. Aoki Katsuo—nearly two meters tall and well muscled—was handsome and he knew it. A shock of short bleached blond hair, tussled strategically, framed the deeply tanned face with strong Yamato features.

He grinned lecherously at her and she cast him a sidelong wink. She let him press up against her body. Large strong hands found the slits on the sides of the dress and groped her naked flesh. She liked how he kneaded her body like a tiger mauling meat. His cock swelled

under the scrubs and pressed into her sylk-covered belly. Grinding her mound onto his thigh, she cock-teased him a while.

Then she twisted out of his grip and danced away, laughing.

"Off the clock now?" he grinned at her.

"You know it." she replied. "Catch me later when the meter's running and I'll give you a little exercise. Looks like you've been cooped up a bit."

"Yeah. He's been a lot of work lately. New med monitors and com tech to set up. He's gotten a bit worse lately too. Both his disease and his temper."

Kasumi held up the download box. "Well then, I'd better get this to the geezer soon so you can get some time off." She grinned. "You know, I want some of what you've got, too." She meant it. She hoped he didn't know that for certain.

"Well, then, don't let me get in the way of your work!" Katsuo stepped back, making a grand bow and a mocking sweep towards the office door. Equally mocking, she curtsied back.

The guts of a space ship had exploded all over Old Man Taira's once spacious office. At least that's what it looked like to her. Complicated machines jutted out from walls in odd angles. Tubes of fluid dangled out of them, hung like weird tropical vines and disappearing into a huge metal cocoon, taking up the bulk of what space remained in the office. It encased a soft, flesh-larvae of brittle, blue-veined skin and dark darting eyes. Wires, not whiskers, crawled out of his face. Tubes wriggled and continuously raped his mouth and throat. Not too long ago, Taira still looked human to her. Even as the disease ravaged his body, he oversaw the company. He used to be seen destroying competitors while dressed in fashionable suits, walking gingerly with an antique ivory cane and speaking with his own quivering voice. Lately there were more and more machines and less and less of the man. Behind the gargantuan Taira empire was a shriveled raisin-head of an old man stuck among a jumble of med machines.

His current apparition disturbed even her. She wondered; was he a man-machine or a machine-man?

The head pivoted towards her just a bit too quickly for her comfort. The trache tube bobbed, his open mouth wheezed and lips moved.

"I hope you've got something new for me tonight." A voice somewhat like his, but flat with each word too quickly clipped, came at her

Midori

from all directions—all directions except from his mouth. Primitives would have thought it the voice of the omniscient God being. It was, of course, a computer voice created from the thousands of electrical signals generated by the face and throat muscles as he soundlessly spoke. "Well?" The walls spoke to her again.

The hair on the back of her neck stood on end, but she tried to hide the creep-out. The old man as a disembodied head and voice was more frightening to her then she cared to admit to. "You know I'm good for it." She stood extra cool with one hand on her hip, the other hand waving around the box. "If you've got a problem I'll quit and you can just rot in your metal box here."

The walls groaned, and then laughed nervously. A robotic arm descended from the ceiling and took the box out of her hand, disappearing back into the machine womb. She snapped a curse at him.

Katsuo didn't even notice their exchange. He went on fussing with some wellness modules.

They were always like this. Taira would try to boss her around like he would the other employees. Kasumi ball-busted him back and threatened to leave. Taira would capitulate. Being cruel to him made her feel like she wasn't owned. It made her feel like she had free will. She didn't know what Taira felt in his ritual surrender to her. At least no one told her anymore to be more respectful of him.

She turned on her heel and left the office-incubator-mausoleum without messing with Katsuo. He knew how to find her later. She passed the tight-faced old Dr. Higa on the way out. She shot Kasumi a dirty look and grunted a greeting at her. The good doctor never approved of the boss' choice in recreational healthcare.

This last download contained a particularly cruel new thrill for the geezer. She'd plotted it especially for his one-month anniversary since the trache surgery and feeding tube install. By the time she returned to her suite, she knew that he'd be suffering from the delirious pleasures of chewing and tasting food.

By order of the Old Man, Katsuo now uploaded each grab box promptly. It used to be that Taira would wait until the end of his day of corporate pillaging to surf on her day's grabbing. As his own neurons disintegrated further, holding him hostage in the tightening prison of withering flesh, the more he craved to be inside of her immediately—or at least in the ghost of her body memory.

~

Laid out on her grand bed in the Taira Tower, naked, covered in paper thin slices of real Kobe beef with Arisu lapping at her sashimi-smeared cunt. This was how he would experience her.

They lay among half eaten trays of gustatory decadence. Half an hour before the food orgy began, she had injected the radiopharm tracer into the hidden femoral artery shunt, starting the recording session that would last a couple of hours. A consummate professional, Kasumi knew how to make those hours count. She ordered up tender raw Kobe beef, flats of the sweet fresh Norwegian sea urchin roe called uni, foie gras de canard with truffles and confit de vin flown from Paris, cod testicle sushi, whale bacon from the base of the dorsal fin, Belgian chocolate fondue, Iranian trifle, Mexican flan and old fashioned Humbolt brownies. She ordered anything that Taira loved, whether she knew what it was or not. Bottles of his favorite wines and whiskies lined the side tables, decanters and iced tumblers at the waiting.

The centerpiece was essential, as she was one of the old man's favorite dishes—Arisu, his beautiful daughter-in-law. Bound by some ancient sense of Nipponnese propriety, he had never made a move on her, which may have seemed unusual for a man known for taking what he wanted. Kasumi liked that he, at least, knew where to draw some kind of a line. Once he hired his grabber though, he did everything possible to bring Arisu and Kasumi together. Kasumi had been more then willing to help him in this scheme.

Arisu was a pale, delicate southern beauty with short-cropped blue-black hair. Her breasts were small and firm, even after birthing Rachel, but her nipples became enormous after the breast-feeding. Erudon, Arisu's husband and Taira's only offspring, found the breast-feeding vulgar. Of course, no one let him in on the real reason chosen to have Arisu milked like some old fashioned wet nurse. Kasumi had talked her into the archaic practice, just so she could suckle and drink the warm flowing milk from Arisu's swollen breasts as she fucked her. That was a special treat that the Old Man couldn't get enough of.

Kasumi lay herself carefully across the bed, moving so as not to disturb the sumptuous dishes and overflowing trays. Arisu unzipped her snow-white Kevlar cover-alls and snapped off the matching boots,

leaving her entirely naked. Sparse black pubic hair formed a delicate delta, beckoning from below the gentle curve of her belly.

"What a feast you have for us!" Arisu shrieked like a schoolgirl and she sat down on the edge of bed. "Most of this stuff is illegal, isn't it?"

"Not to your father-in-law, apparently." Kasumi grinned.

"We're feasting for him tonight, I see," Arisu said, licking the chocolate-covered finger Kasumi offered her. Arisu stared into Kasumi's eyes and through them. "Well, dear father, enjoy every bite, lick, and swallow!"

Nowadays Arisu simply accepted that their sex life was grabbed for her father-in-law. It must have been some sort of double betrayal acted out for her. From time to time, she would look into Kasumi's eyes and speak as if speaking to Taira directly. In the early days of their affair, she had insisted that that Kasumi not upload their trysts. Kasumi would hold her lovingly while promising with profound sincerity not to, and then record the session anyway. Arisu would find out and she would cry, scream and pound on Kasumi. Kasumi recorded that, too. She had a job do and the Old Man could not get enough of his sweet young daughter-in-law. And in the end Arisu had relented.

Arisu swirled a glass of rich red wine in a crystal glass under Kasumi's nose, letting her inhale the heady bouquet. The alcohol fumes saturated her nostrils. She mouth-breathed deeply, letting the rich tannins tickle her throat. The geezer loved wine and now he couldn't drink any. He couldn't drink anything, actually. So she would drink and eat and fuck to torment his senses. Full of berry and oak, the wine filled her mouth, bathing every taste bud with complex flavors of sun, rich soil, and deep forests. She drank more, passed from Arisu's vino-filled kiss, sucking in her lips with it. A tender tongue probed her mouth while the alcohol burned down her throat. Arisu scooped a handful of jelly-textured uni and smeared it across her own lips, down her throat and across her firm small tits. She clambered atop Kasumi, straddled her chest and leaned down to her face. Arisu's wet cunt pressed into Kasumi's belly as Kasumi licked at the uni-covered nipples, sucking up the delicate rose and sea salt flavors. Arisu slid down Kasumi's body, offering her uni-smeared collarbone and wine-dribbled neck. Their legs flew and intertwined. By the time Kasumi's licking reached Arisu's sea-salty lips, they were grinding their swollen pussies into each other.

The Old Man would feel everything Kasumi experienced during a

grab session. He would taste exactly what Kasumi savored and how. He would hear what she heard. He would feel all skin sensations, heart-rate alteration, neural chemical shifts of pleasure and muscle contractions. He would see what she saw and breathe in the scents she wallowed in. He experienced everything she experienced—everything except for her thoughts. For which she was grateful.

She eventually learned to control what he could experience during playback. It was simple, really. Once when she was pissed with him she refused to look at Arisu as they fucked, and then didn't let herself come, just to punish him. It worked. He capitulated and gave her whatever whim she had demanded after that download session.

So they devoured the illicit foods off each other's bodies and fucked like sharks tearing apart a drowning sailor. They locked into a sixty-nine, slurping toro and whale meat off of the fleshy lip,s and thrust tongues and fingers into one another. Kasumi made Arisu frig her pussy with a shaved ginger root, just to feel the intense burn, simply to make Taira burn in a cunt he didn't have. She wondered if he wished he were a woman. Kasumi knew that he often cursed his own decision to hire her. It wasn't just her cruelty. The grabber tech he used on her required him to be bio printed to her neural waves.

The two women orgasmed in waves after orgasmic waves. They mixed the ejaculate with a touch of soy and dipped the cod testicle sushi in it. Once they were sated of sex and food, they fed each other Humbolt brownies so they could eat once more, which of course led to more fucking, until somehow, Kasumi ended up fucking Arisu hard and deep with an intact piece of well-gnawed Kobe beef bone the size of her forearm. They screamed and laughed at the grotesqueness. They cackled out loud how a dead bone could fuck her better than a withered old man.

They were co-conspirators in the continual arousal and degradation of the man who controlled their lives, Kasumi because he paid for her and owned half her central nervous system, Arisu because her own husband was under Taira's dictatorial paternal thumb.

Only after all the food had been destroyed, the bedroom turned to a culinary war zone, and they had screwed several orgasms worth, only then did Kasumi understand what Arisu had said earlier. They were finishing off the flan and laughing as usual about the sexual impotence of the most economically potent man. Somewhere in that, Arisu had said "Well, it's not like he's going to stay on much longer.

Midori

Erudon's making sure of that." Then she paled briefly, tensed and quickly changed the topic. Kasumi had just let it go, pretending not to hear. There was nothing to discuss. It was their business.

So they showered together, washing and rubbing each other thoroughly, using up every bit of the remaining recording time. The grab of this feast was a special gift for Taira, designed by Kasumi to twist the knife of hunger in his soul. With the trache tube, feeding tubes and IV, he would never taste, eat or swallow food again.

But this was not the worst thing she'd ever done to him. Nor was the various occasions of denying him her vision of Arisu. The cruelest thing that she had committed upon him was screwing his own son, his own flesh and blood, Erudon—an act she was very proud of. She seduced the heir-apparent about six months prior, insisting that she would not grab their affair. She kept her word long enough for him to relax and let down his guard. Maybe even trust her.

He was not a bad-looking man. Fit and trim in his mid-thirties with a well-groomed face. He worked the media smoothly, smiling to promote the newly established robotics branch he headed as well as the many philanthropic efforts of the Taira Corporation. He was the model son, the perfect zaibatsu prince. He was also cold, calculating, and success-hungry. Publicly charming, he was not known to be warm within the company or his own family. This drove Arisu into Kasumi's delighted arms and and Taira's sexual scheme. The Old Man must have enjoyed hearing Arisu cry over what a poor lover/husband/father his son was. Erudon was too busy to catch-on to the two women's affair. Or maybe he just didn't care and turned a blind eye to his trophy wife being kept out of sight. He did, however, seem to dote unusually on their infant daughter, Rachel.

Kasumi decided to seduce Erudon out of petty revenge against the Old Man. She figured it would be good for job security to start being the mistress to the heir-apparent while the aging king still ruled. So for several months, she sucked cock and rode his rod off-the-clock. Then, she began to execute her plan of revenge recordings. She'd fuck a fellow femme grabber and then, during the same grab session, get a quick and nasty screw in with Erudon. These recordings were pure torture for the Old Man. He'd plug in, get worked up being in Kasumi's body fucking or getting licked by a girl. Then he would gaze at his own son's thick cock through her eyes. His mouth would feel his son's cock pound her mouth. His tongue would taste his son's

semen bursting its salty-bitterness into her mouth. It was pure hell. She knew he didn't have the choice to log off. He had to take the whole ride because logging off mid-playback was guaranteed to fry his circuitry and spinal cord.

She saved up those recordings for those special occasions when she wished him worse then dead.

She also kept Arisu in the dark about getting it on with Erudon behind her back. If Kasumi was gone, Arisu assumed she was trolling the bars or the grabber dorms.

But now Kasumi knew. She couldn't shake the thought. Was Erudon really plotting to deep-six the old man, or was that just the mutterings of a bitter and angry wife? She didn't know for certain, but she didn't trust him not to, either. For some unknown stupid reason, she felt pity for the Old Man. After returning from delivering the box, she sat in her dark, food-covered room and thought about the situation, thought about employment security and thought about kinfolk.

Eventually she rose and ran a scanner to check for the radiopharm load level in her blood. It was still pretty high, she knew she could push it a bit for another session tonight. And she could take a break from grabbing tomorrow.

She called Erudon on the holo wall and caught him in his office. Perfect.

"Good timing on your call, Kasumi. I need to blow off some stream."

"I figured. That's why I called," she said nonchalantly.

"How did you know?"

"I know you had one of those parties. It was on all the ether blogs and internal news. You always need me to take care of you after those. You get so wound up having to be cheerful." She rolled her eyes at him while leaning into the holo wall, licking her lips with a pink undulating tongue. "Or would you rather I leave you to the ministrations of your dear, sweet wife?"

Erudon laughed. "You can spare me that favor!" He didn't miss sex with Arisu after Rachel was born. He figured her desire dropped as some post-partum side effect. Or maybe he got the product he wanted out of Arisu so he was done with her. "Come over in an hour to my office and I'll plow you good."

He disappeared from the wall.

Midori

T
h
e

N
u
r
s
e

Before going out to meet Erudon, she injected another tracer into the femoral shunt. Undoubtedly Taira would suffer through this grab while she screwed his son. But if he managed to not gag himself into utter distress, maybe he'd hear something interesting—an incriminating confession she was certain that she could draw out. Then he would certainly have to do something about his own Oedipus Rex.

In any case, things were getting interesting at work for her.

LOVE

I love him.

It's really as simple as that. It's pure and strong. Ours is not the mundane debasement of the word used like some cheap salve to soothe cracked hearts. Our love is so deep, so powerful, it frightens people. I'm sure that's what happened to my friends, I'm sure of it. Poor souls, they must feel woefully inadequate in comparison to our love. He is magnificent and profound. Next to him, of course they would feel laughably pathetic. You have to forgive them. They're weak. If they were to truly understand my love, my devotion, they would come to realize how pale and false their lives are. I must forgive them, for they do not know what it means to be truly alive.

They're jealous of him, that's for certain. His physical splendor alone invites raw attraction, awe or resentment. With a powerful body of strength and grace, half a head taller then most men, he gazes down onto others with deep black eyes probing into their souls.

With each glance he probes into the very essence of my existence. He penetrates into the farthest reaches of my fears—and finds love that I never knew I could feel.

Tonight, he comes to me earlier then expected. Of course I've been here waiting for him, in the manner of his pleasing. Within the world of my closed eyes I have been tracing and retracing the shape of his steel-toned body when I hear the airlocks release. The others' murmurs stir the stillness of the darkened Chamber. I keep my eyes shut for a moment longer, listening for the whirring of the elevator platform.

With a muffled metallic sound the platform drops to the Chamber

L
o
v
e

floor. His first step clicks hard on the pristine white tile floor. Thump goes my heart and my uterus contracts. The wires carry the impulses to the monitors with green glowing faces, recording my arousal to my master's arrival. I am Pavlov's bitch.

These monitors connect us, through time and distance, showing him my devotion even when I can't serve him in the presence of my flesh. Whenever the whim strikes him, he reads the charts and data of my day's activities. At any time, he may be caressing the digital traces of my body's devoutness to him. It's my only hope that the patterns are pleasing to him as I am pleasing to him. The wire attachments and tube insertions are his caresses. Sometimes I play with simple biofeedback to make the data dance, so he can read me thinking of him.

Even when he's away, he can look in on me through cold glass eyes of the camera to see me doing his bidding. I whisper my love for him to the camera as often as possible. I know that he's watching. At all times I am under his loving care and protective eyes. If my bio signs falter, should I have a fever or illness, he's alerted immediately and attends to my care. Several months ago, when an implant modification failed to take, a flesh-eating infection ravaging my organs, he was there beside me, tending to me. Searing pain from the infected wound stabbed through the bizarre hazy dreams as the fever boiled my brain, It wasn't the sweet pain he could give, but the cruel bubbling pain of rotting alive. Through harrowing days and nights he stayed with me, cured me, using his medical skills to save my life. Had he attended with such fierce focus to the wounded soldiers and captives on the fields of battle so many years ago? Were his soldier-patients as grateful to him as I am? Once again, my heart pounded in his palms. It was as it should be, for he owns my heart.

I open my eyes to see the iridescence of fluorescent lights coming on behind me. The darkness flickers away spastically, replaced by blue white pools of light glowing over each housing unit. He is still behind me, strolling around the Chamber. His step is light as he whistles merrily. Is he a bit drunk? How adorable!

Murmurings and whisperings mingle with the low but constant mechanical clattering, the purring of fans, pumps and gears. His voice weaves between the low hum of the med monitors—the song of a single lark among swaying rice stalks. The sweeping sound of the cleaning drone fails to drown out the pleading voices. The others beseech him for so much; for attention, for comfort, for freedom and

even death. I stifle my irritation at their ungrateful simpering.

Nobody loves him, understands him, and serves him like me. My submission wasn't always perfect. He struggled to teach me, break me of my willfulness and own me despite my resistance. Like these ungrateful newcomers, I thought I was better off alone, to follow my own will and destiny. Who was I kidding anyway? I had no real future, no real hope. Not in this filthy city. It wasn't like I was some pathetic hooker or street junkie. I had my bad habits but I thought they were well enough in control. They kept my mind off the boredom of the lucrative yet mind-numbing job. Biomimetics R&D for the zaibatsu barons paid sweet enough to keep me comfortable, to rate with the label gals, wear the latest threads and party with the trendboys after the lab lights went off. Life should have been perfect and good. I had it better then most of the dregs in ShinEdo. The truth is, underneath all the sparkles and glam, I was a wretched loser. At work or play, people never wanted to know the real me. If they did want to get close either they were totally superficial and stupid or they just wanted to use me.

He is different. He wants me for the essential me, the person that I didn't even know existed, the person beyond the flesh and fakery. When I first met him, I didn't realize how fundamentally different he was from all the other men. Sure, I noticed his looks—everyone did. But he was confident to the point of overbearing, and I wanted to take him down a notch and humble him. My experience had shown me that all hetero men were reduced to babbling ape children in the presence of hot pussy. Debasing the boys before they got me was a casual sport for me and my 'horts. Everything was much easier that way, and it gave my gals something to banter about on the ether during the boring day job.

The first time we met, one of those boozy company functions, he didn't fall for any of the usual tricks. leaving me infuriated. The second time we met, a week later at the Head Quarters, he stepped into an elevator with me. I started in on him all amped up. Several floors passed. I figured he had to be queer, so I was about to give up when somewhere in the 150s he grabbed my wrist, held it in mid air and said nothing. I bitched and kicked at him to release me but he would not. He whispered low with the voice of an impending earthquake, a voice that came from somewhere deep in the core of Earth, "You will do as I say." With that, the doors slid open and he pulled me into a

L
o
v
e

brightly lit reception lounge. He stalked over to the glass wall over-looking Edo Bay, dragging me along like some piece of luggage, strong fist clenched around my wrist until I felt my own pulse in his grip. He pushed me against the window. I looked below and saw the sun sparkling and dancing on the oozing thick water below. Then I heard him give his first command to me—I didn't so much hear it with my ears as felt him in my gut.

"Strip."

This distinct command, not like some predictable threat but a sim-ple word that recognized my inner truth, started something-something big. His earthquake voice triggered a tsunami, coming at me as a massive wall of desire. As it swallowed me up whole, the world went frothy and black and I tumbled. Then I was scrambling to take my clothes off, leaving the lab coat dangling on my wrist where he still grasped me.

That was so long ago. I really have lost track of time. Now I am his-utterly his, his creation, his slave, and his muse.

The clicking of fine Italian soles on sanitized white tiles grows louder as he makes his way through the Chamber towards me. Nice and easy with a long, smooth gait, accompanied by a cheery tune whistled with clear notes. Is it an old Argentinean tango? Even the simple act of sauntering is an act of grace with him.

A shadow comes into the left edge of my field of vision, growing larger. I cannot see him clearly soon enough. I fidget and try to turn my head but am blocked by the cell padding. I curse the left ocular install for not taking well to my flesh. I want to gouge it out myself and put a new one in just so I can see him a moment sooner. A moan escapes my throat.

Eventually he moves into my line of sight, just a few steps away from me. He wears a crisp yellow Mandarin tunic with clean metallic maroon trim that flows to the floor. It is partially untoggled in the front, showing just a hint of his carved pecs and deeply furrowed sternum.

As usual, I keep my gaze down, looking no higher then his throat. I dare not look into his eyes for fear of his immense displeasure. But the sight of his half-exposed chest excites me. I crave his touch like no other craving. I crave the rush of his pleasure at my suffering. I roll my hips forward and present myself to him in my full nakedness, cunt out and swelling slowly. As I roll, the scars on my thighs contact cell

padding and pain shoots through me. Feet twitch and kick against nothing. The phantom pain shoots through my spine. I no longer bother to control legs I no longer have. The amputations were not well repaired. The legs he sawed off in the early days are determined to haunt me still. My brows furrow and lips twist in the surge of pain. He makes a faint grunting sound, so I know he is smiling.

I have pleased him. So I rock my hips again to let the pain shoot into me once more. He smiles even broader and begins to unfasten the tunic further, showing hard pecs. Finally the tunic opens fully, falling back from his fine form. His divine cock is fully erect. I have pleased him.

He steps closer to me and rests his right hand on the cell housing. He spits a great gob of mucus into his left palm and reaches down, thickly grasping his magnificent erection. Oh, how I wish to wrap my lips around it. He teases me with the sight of his swelling cock, the head plump and darkening under each twist like a carnivorous plum. His gaze caresses my form. I burn under it. I squirm, letting the newer wounds stretch and pain me. My uterus knots and contorts itself around the nanometerics inside and screams my desires along the wires. My breasts and cunt lips swell with each lush stroke of his cock through his fist. The plum head begins to ooze, making my cunt ooze. The engorging cunt signals the wires into my breasts, making my nipple mouths open, blindly seeking his flesh to suckle on. The pair split open into an obscene fleshy-lipped grin. These are the alterations I've come to enjoy, so many new holes he's sliced and gashed into my flesh—my flesh that was meaningless until he gave it meaning.

My heart beats faster and it roars its machine roar in my head. It is his heart, truly.

It wasn't long ago that I lay on a cold steel platform before him, med blessed but fully conscious with a spinal block. He gazed down onto me. Even through the surgical helmet shield I could see his dark eyes glisten. I pleased him. AI eyes on twisting arms peered down from the machines. A dozen screens around the room flickered with the close-up of my devoted smile and directed it all around. I could see two of them just behind his head, aimed at me. (I heard sobbing.) The machines watched and assisted, but he would not let them auto-operate. He reserved that right for himself. He picked up a scalpel. (A man-

Love

ual device of such antiquarian concept!) He leaned in and I saw the incisions on the screen. His fingers are long, his hands handsome and his motions perfectly controlled. I could not feel this cut and I wished for it so hard that I thought I could feel its sweet, sharp pain. Silver tip plunged precisely into chest. (More sobbing in the distance. Won't they stop?) He peeled the skin back. He reached for the laser bone cutter. I watched white bone dust float into the air like champagne effervescing. (Someone began to vomit uncontrollably over herself.) Over several hours of total attention to me, he cut, sewed and manipulated my flesh with tubes and wires. For one moment I was an impossible chimera of two hearts beating: one flesh and one crafted. With the new heart in place and my heart beating in a preservation bowl beside me, he sealed me up. (The sobbing continued from many corners. He made them watch.)

I was light-headed. Unconsciousness tugged at me. Through my heavy lids, I saw him pull his helmet off, take his gloves off and cradle my beating flesh heart in his hand. He held my heart in his palms. I gave him what he craved that others could not, would not give to him. The mind and the flesh of those before failed him. I did not fail him. I knew that he would love me more now. Before I sank into the darkness, I saw his mouth open wide, wider than the gaping chasm of hell, and he bit into my heart. It spasmed, and squirted blood in great gobs onto his brow and cheeks. He thrust his eloquent tongue into it, boring a hole into it, sucking at the dark life-blood. I cannot be certain but before I faded into blackness I think I saw him fuck the hole in my heart.

Since then, he's taken much of my flesh that is meaningless and redundant. He's replaced so much of the flawed flesh with beautifully crafted works of biofunctional art. I am his canvas. I do not fear anymore. He has taught me, sometimes harshly but necessarily, that my fear keeps me from true submission, keeps me from giving myself fully. He will not love me if I do not give myself entirely. I struggled, begged, pleaded, and wept. He beat me and then caressed me. He showed me the way. Now I am here.

Now I am here with him and his magnificent cock before me. My machine heart roars, my pulse races through my body. My many openings, original and new, open to him. My leg stumps quiver and pain me. My face twists at the sensation, which causes him to stroke a bit faster. I let the muscles of my right arm stump tighten, making

the machine claw open and then bite down onto the remnant of my thigh. I scream. He moans, leans toward me and strokes faster. My pain mesmerizes him. I must create more pain for him. I roll my left shoulder forward, whipping the grafted tail-tentacle thing from my right shoulder around my own neck. I roll the shoulder back and my new appendage constricts intuitively around my breath. I keep the panic at bay by counting his rapidly increasing strokes. My breath becomes ragged and my face must be turning dark. He gazes into my eyes as if he's going to fall into me. I look back into his eyes without the worry of punishment. A reward. He groans. Strokes. Grunts and then with great fountains of whiteness comes at my face. His seed smears across the plexiwall of my cell. I want to lick it, but it's beyond me. I want his love but I am not worthy of him yet.

(I twitch my shoulder and my arm thing releases me.)

But I deserve him more then the others. They could not possibly love him as much as I do, give him as much as I do and suffer for him as I do. I please him. I know that.

Today, he comes to me exactly at the appointed time.

I am strapped into a cold surgical chair. He is touching me direct-ly. No plexiwall to keep us apart today. There are new machines around me as well as the AI eyes. Their lenses stare at me as usual and the screens show me from every angle. They show me to all the oth-ers. (They are already sobbing. Such weaklings. Why does he keep them and gather even more of them?)

He has told me he could love me, but that I am weak. He has shown me that I am too attached to my flesh and my sense of self. He has shown me that I am still attached to my memories. I now agree with him that renouncing my family was just not enough. That was just lip service really. What is my flesh and my life after all? What could possibly be sweeter the bliss of loving him beyond thought and cognition?

I am ready for this.

And now I will deserve his love.

He stands before me in his surgical garb and sterile helmet. I can see his dark eyes dance and shine like never before. I am pleasing him.

He checks the program and machines. He inspects each of the sur-gical assistbots. He is satisfied. I see and think but the sensation of my face and head is gone. He is kind in numbing me so. This is how I

Midori

know that he really does love me. I must be worthy of his love and to keep his love. What could be more important?

I watch on the screen as his elegant fingers curl around the old fashioned scalpel, cutting my scalp swiftly and rolling it back like a red-stained rug. The laser cutter hums. The white effervescent dust floats and flecks before my eyes. I savor my cognition and thrill at the thought that soon I shall give that to him too.

The bony skull pops off like the lid of a tin candy box. My brain, my mind and my sentience lay open to him. Ever so carefully and gently he caresses the membrane with his gloved finger. Is that awe that I see in his eyes? He lifts the visor and takes off the helmet to get a better, closer look. I see on the screen how close he is to my brain. I wish I could feel his breath.

Gently he licks my brain sac.

Then he draws back, kneels down, takes my hand in his and looks me in my eyes. Such a treasure! "Will you give yourself to me now?"

(Somewhere far away I hear hysterical sobbing.)

He hands me a remote control, one of those antique devices. The largest button is red with the word "play" on it. Written over it are the words "Love & Serve." I begin to cry. I will press this and soon he will love me for the gift I give him.

The red rubber button is soft to my touch. I press it in hard as he gazes glassy-eyed at me. An arm emerges from a stationary assistbot. The jointed arm ends with a spoon, a simple kitchen spoon. How quaint. I see the spoon arm reach toward me on the screen. Then it breaks the brain membrane. It thrusts into my gray pudding brain.

Bewildered, the older detective scratched his head while the younger one vomited off to the side. They had seen a few bizarre murders and hacked up bodies before, but this one was unlike anything they'd seen before. She was found floating at the end of the Sumida Trench. They were certain the Jane Doe was a female, but beyond that, they just weren't sure. No prints would be taken as the legs and arms were gone. Most of the internal organs were missing, including the brain. Blind camera lenses protruded where the eyes should have been, and the brainpan was empty with precision cuts. Her mouth contorted in an eerie smile. Then there was this thing—this arm thing just flopped, still alive. The younger man stood up just as the arm thing twitched towards him. He twisted and retched again.

Your Documents, Please

Yamada Shinji finished the tepid green liquid that passed for tea and placed the stained white polyporcelein cup into the staff room dishwasher. Looking into the tiny locker mirror, he straightened his uniform. Fastening the top two snaps made the stiff band collar stand snugly against his Adam's apple and clean-shaven jaw. The dark gray militaristic jacket with highly polished brass buttons and trousers fit him well. He had it tailored just after the recent promotion. It had been a year since he graduated from the Civil Service Academy and he was right on course. Perhaps immodestly, he liked how his body looked in this uniform. Before the Academy he wore the uniform for a Northern Region baseball team as a relatively successful minor league pitcher. Even after a few years of deskwork, his body was still trim and fit, and now that he'd moved to the big city, he wanted to look especially crisp in his uniform. It was a matter of country pride. He also wanted to impress the supervisor he'd been assigned to.

Ms. Tanaka was just a few years older than Shinji, perhaps in her mid-thirties, but she had been with the Customs and Immigrations Department for many years now. She had a great deal of seniority and sway in the department. Sometimes, it seemed to him, that her sway was more than that of the usual person of her rank. Working under her proved quite beneficial to him, although he wasn't always comfortable with how she arranged for those "benefits." She made deals with the companies and individuals that came through this legal port of entry, and some not-so-legal entry points. He entered the Civil Service fully believing in his duty to serve the nationalist interests of Nippon. He believed that in his position as an Immigrations Officer he served as the first line of defense against undesirable elements such

Y
o
u
r

D
o
c
u
m
e
n
t
s,

P
l
e
a
s
e

as criminals, terrorists and blackmarketeers. Over time, much to his moral discomfort, he became aware of her talents beyond that of an exceptionally good full-time civil servant. She also excelled with her equally full-time bribery and deal making. This was, she quietly insisted, the way that things got done in ShinEdo.

How she operated was wrong, by all that he was taught, but he could not simply scorn her, and he certainly could not dislike her. In her own officious and corrupt way she looked after him and mentored him. When he had inadvertently offended a higher-up in the diplomatic corps, she bowed and apologized for him. That incident could have killed his career. When he failed to pay the neighborhood protection fee to the yakuza on time, she coached him in how to fix the situation and save face for all concerned. She saved his country bumpkin ass on many other occasions. Perhaps befriending him was simply her way to cover her unofficial profiteering, but he wanted to believe that it was more than simply alibi-making. He wanted to believe that she was a fundamentally good person who was simply good at making the best of the labyrinth city.

His cock stirred.

The simple dick-based truth was that he couldn't dislike her because he wanted her. At first, he didn't notice her attractiveness. She seemed a picture of efficiency and official decorum with her precise uniform, unpainted face and tightly controlled hair. He did not notice the silky luster of her jet hair nor did he see the pink flush of her fleshy lower lip. At first, he was simply too overwhelmed with his new assignment to notice her petite body. Beneath the dark gray uniform her small, round ass filled the trousers much to his distraction.

His cock swelled.

Perhaps she liked him, perhaps not. Soft-spoken with a disarming smile, yet firm in her commands and demands, she exemplified officiousness, even in her day to day dealings with him. They never socialized outside of work. He didn't even have the nerve to ask her out to the sake parlor frequented by the Department personnel. He would have happily settled for some private time in the office.

He was grateful for the length of the tunic jacket as it just covered the tightening trouser crotch.

He regularly indulged in inappropriate fantasies of Ms. Tanaka. Last night was no exception. Lying in the narrow bunk in his small res-tower cube, he imagined the curve of her hips in his hands, her

body bent forward over the desk of their shared interview room. He could feel the tightness of her cunt and softness of her ass as he pounded into her. In his mind her body would rotate around freely, where he'd fuck her doggy style one moment then have her trim legs wrapped around his neck while her pumped her hard the next. He'd fuck her so hard that she'd scream. She's scream his name and claw at his sweating flesh.

She would multiply in bodies in his wanking visions. He fucked many of her at once in every possible direction. While he fucked her tight cunt, she'd lick her double's 69-ed cunt as that double licked his balls, all the while he ate out another of her dripping, wet, pulsing cunts grinding onto his hungry face. Her many hands from many bodies, six, eight, a dozen, would roam over his body, caressing skin, ticking balls, pinching nipples and grasping his swollen cock while he pumped all the holes that he could find. Her hair wild, tits dripping with come, cunt, mouth, and asshole open and willing, he'd thought of every possible way to pound her flesh as his own hand pumped busily at his lonely cock. With a deep grunt he gripped the base of his cock hard, then with a long spasm he shot hot jism over his chest and onto his chin. He licked it off his hand, tasting its bitterness and wondered how it would taste licked out of her wet, well-fucked cunt.

After jacking off to depraved fantasies of banging her silly, he always felt a bit guilty, and wondered how he'd be able to look her in the eye the next day at the office. He managed to report to her each day, of course, accompanied by a guilt-spurred half-hard-on as he met her matter-of-fact gaze during the morning briefings. His feelings for his supervisor were, he was convinced, wholly inappropriate. What if she found out about his fantasies? He could be disciplined, lose his post, lose her benefactoral kindness or worse still, it might cost him his daily physical proximity to her. So, each night he would jack off and each day he'd put on the good company-man smile and work side by side with his object of lust.

It was yet another such morning, and he survived without blowing his wad in his pants while watching her luscious mouth move and lips curl forming the words of the eternally dull staff meeting. After the briefings they moved to the Interview Room. Essentially a windowless gray concrete bunker of five meters by five meters with a low ceiling, tile floor, and soundproof walls, the room lacked any comforts whatsoever. It was one of many identical rooms. The two of

Midori

them sat in old ergonomic-design chairs just behind the massive gray metal table strewn with screen tablets, tea cups, stamps, assorted forms, palm and retinal scanners. The aging fluorescents on the ceiling cast a sickly, flickering pallor on the people interviewed. The security camera mounted on the far corner from the door stared prominently and intrusively at anyone seated in the hard metal chair of the Applicant. The Applicants didn't know that most of the time Ms. Tanaka disabled the camera so she could make her deals with ease and discretion.

Most of their working days were spent here, interviewing foreigner after foreigner. For each case, Shinji compiled the data on the tablets based on the bio scan reports and scans from passports, immigration documents and shared files from other agencies, both national and international. She would read over the data with great care and focus, punctuated by periodic grave frowns that wrinkled her smooth brow. She always took at least thirty minutes to review each case, even if they only had five minutes worth of content. During which time the Applicant would squirm. This was her method, of course. The experienced Applicants simply offered early on whatever bribe they had to offer. The smugglers were the easiest. They simply figured this into their cost of business. The political asylum seekers were the worst. The procedures and red tape created an enormous headache. They usually had nothing to offer and their desperation made the whole transaction clumsy. Inevitably, someone lost face in bitter humiliation, and it never was the officers.

The day in the Interview Room progressed with the usual parade of smugglers from the Stans, flesh brokers from North Siam, wealthy tourists from Arab Alliance, technocrats from the EU and a few pitiful refugees from Terra Nova America. Letters of introduction, yen cards, exotic items such as organic furs and uni crossed the table and into the deep drawer next to Ms. Tanaka. While he was never quite sure of the value of the items in the myriad bags, envelopes and boxes handed to her, at the end of each work day, a portion of the dealings would appear in his locker in the form of an unregistered yen card which smelled faintly of her soft floral perfume. Her scent turned him on so much, once he jacked off in the office stall while sniffing the card.

That afternoon, shortly after processing a "business man" from Shanghai, a tall young man opened the heavy steel door and quietly approached the desk.

*H
a,
n
s
D
a
u
g
h
t
e
r*

"Please take a seat." Ms. Tanaka smiled softly and gestured to the hard metal chair. "Mr.—?"

"Chin, Jon Chin. Thank you." He smiled stiffly and sat down with the tentativeness common to first time interviewees. He looked to be in his early twenties but his voice and posture presented the gravity of one much older.

"You're documents, please." Shinji stood up and reached his strong ex-pitcher's hand towards the Chinese man. Mr. Chin, a fair-complected man with lanky limbs, rummaged through his carry-on bag with elegant fingers, eventually produced his passport, flight itinerary and a sealed white envelope. The golden orange cover of the passport read with elegant crimson print "The Corporate Republic of Singapore: Singapore Inc."

"Please place your right hand upon the scanner pad and your right eye to the scope. Please keep your eyes open until you hear a beep," Shinji said with the habituated tone of bureaucratic courtesy. Mr. Chin followed the instructions promptly, sat back and waited for the next instruction.

Mr. Chin stood over two meters tall, unusual for an ethnic Chinese, even from Singapore. On the other hand, he was slight in build, a feature more common among his people. His long neck turned elegantly as he moved and his facial features were refined. Gently curved high cheekbones and a slightly downturned nose framed his dark eyes well. His eyes cut graceful lines like precise sumi brush strokes. The fullness of his lips showed his southern heritage. His black hair was cut in a shaggy style just to his chin and highlighted in streaks of bright red and yellow, a style popular among the boys and girls of the wealthy. Singapore Inc. grudgingly allowed men to have such styles, as long as it did not touch the shoulders.

After a few short moments Shinji's tablet blinked and the data appeared. As Shinji began to silently review the compiled reports, Ms. Tanaka tore open the sealed envelope.

"Oh, really?" she said with a voice full of curiosity. Shinji looked up as the unusual tone of her voice registered in his brain, dull as usual in the late afternoon. "Do you really mean this?" she said, with an unusually firm voice.

"Yes," replied Mr. Chin, quietly yet with determination. "I hereby formally request political asylum and permission to enter and live in Nippon."

Midori

"That's rather unusual, coming from Singapore Inc. Usually everyone wants to move there. After all, isn't it true that the incorporation of the country has provided for even greater wealth and comforts for its good citizens?" quizzed Ms. Tanaka.

"Yes, that's true, and I still formally request political asylum and permission to enter and live in Nippon," repeated Mr. Chin with even greater emphasis.

Ms. Tanaka looked to Shinji with a puzzled look on her face and handed him the letter. It simply stated in one concise sentence exactly what he'd said, accompanied by his signature, passport number and a family chop mark in red. He had done his part fully in initiating proper asylum procedures. They now braced for the official questioning sequence and the procedural nightmare to follow.

Shinji snapped out of the befuddlement and returned to the blinking data tablet. This time it was Shinji's turn for the surprised outburst. "What on earth? Let me see your passport again, please." He handed the data tablet over to Ms. Tanaka as he looked over Mr. Chin's passport again.

This time Ms. Tanaka did not take twenty minutes to begin asking questions.

"Are you aware that there is a reward out for locating you?"

"Yes, I am."

"Are you aware that it is offered by a Mr. John Chin?"

"Yes, that is my father."

"Are you simply missing or are you a criminal?"

"I have left home against my father's wishes. No, I am not a criminal, but they do believe I am socially wrong for the order and harmony of the Corporation."

The screen indicated that there was a pretty hefty reward out for information leading to his retrieval, but it was neither a warrant of arrest nor a notice of a potential criminal. The reward, however, was issued for Ms. Joan Elizabeth Chin. The rest of the records, passports, travel documents and bio scans were a hodge podge of the names of Joan and Jon.

"Have you undergone gender reassignment?" Ms. Tanaka asked. This surprised Shinji, as he had never met a gender morph, or at least not one that he could recognize. He began to search the applicant's features. He looked to the chest and it was flat. He looked to the crotch and the jeans seemed to have some significant content. Yet the

features were too fine. But hadn't he seen many androgynous Continentals?

"No, I have not. I am as I have always been," said Mr. or Ms. Chin calmly. "I seek asylum because I do not wish to have such a surgery."

"But reassignment surgery is illegal in Singapore Inc.," said Ms. Tanaka, seeming a bit cross with the mounting mystery and Chin's calm. Asylum seekers were always on a desperate edge, which gave her the upper hand. This was not the case with Chin.

"Yes, but only for elective reassignment." Mr./Ms. Chin said. "You have my bio scans. Why don't you take a careful look at my chromosomes?"

Shinji quickly scrolled through the fine print, reams of detail usually ignored, and found an odd string of codes under the birth records. He cross-referenced them and found four chrome codes instead of the usual two. He passed the information to Ms. Tanaka. They looked at each other with unmuted surprise.

"Yes, I am all that," said Mr./Ms. Chin, as if reading their thoughts.

"Tell us more, please," asked Ms. Tanaka, no longer able to hide her raw curiosity.

"If I go back, they'll force me to the butchers that they call surgeons. I do not fit into the corporate culture and they do not wish to draw unfavorable attention from outside corporate influences, so they need to find me now. My mother hid me, and my true identity, for years, but now that she's dead I have no more cover. My father learned the truth about me last year, and now he desires for me what he thinks is the best for me. He has no idea what's best for me. So, I seek political asylum."

Ms Tanaka knitted her brow and spoke officiously. "We cannot grant political asylum to a permanent employee citizen of a corporation."

"What?"

"No, really. You don't come from a nation-state. You come from a corporation. We are a nation. We cannot grant you asylum."

"But you must!" he barked and nearly jumped out of the chair at them.

The desperation, certain in all asylum seekers, finally started to reek in the room.

Ms. Tanaka smiled her moray eel smile. "I understand that you desire greatly to enter our beloved Imperial Nippon. I'm sure that we

Midori

can find some way to accommodate your wishes for some sacrifices." She walked over to the disabled camera and made a grand gesture of turning it off.

"All right," said Chin in a resigned tone. "I understand. What do you want?"

"What do you offer?" continued the beautiful moray. For some reason Shinji always began to stiffen in his shorts when she turned the heat up on the Applicants.

"I have nothing of worth. You are welcome to look through my bags if you must." Chin pointed at two small duffel bags. Shinji began to walk towards them when Ms. Tanaka gestured for him to stop.

"You have something of worth I've never had." The grin split open and her mouth crept into an unusually lascivious expression. Ms. Tanaka rose from her chair, walked around the large desk and hopped up on it just in front of Chin. "I've never seen an unaltered and authentic third sex before. If I like what I see, I may permit you entry under a conditional work visa."

Chin looked at her for a while. Ms. Tanaka smiled back. Shinji stood in stunned silence, having never seen her show any sexual impropriety. She spoke to Shinji without breaking her gaze upon Chin. "Relax, Yamada. Chin and I are just coming to an agreement here. After all, don't you want to help avert a potential human rights violation? Would you want this charming person to endure forced castration?"

Shinji winced, his dick lost its semi rigidity as his balls shrank up to seek protection. He could, after all, see her point, all too sharply.

Chin and Ms. Tanaka silently squared off, until Chin let out a heavy sigh and looked down. "I understand," s/he said. Ms. Tanaka's legs began to swing eagerly like a spoiled child who just got her way.

Chin stood up and pushed the chair back. S/he unzipped the blue lightweight body-armor windbreaker and pulled it over hir head and carelessly tossed it on the concrete floor. Shinji stood dumbfounded, not knowing what expect from either the Applicant or his supervisor. Underneath, Chin had on a regular T-shirt, black, cotton and unremarkable. The chest looked perfectly flat and thin, presenting the torso of an overly delicate young man. Chin peeled the T off over hir head and revealed a densely knit, tight-fitting, flesh-colored microfoam tank top. S/he peeled that off as well. Shinji sucked in air so quickly that he choked. Ms. Tanaka purred "Mmmmm, yes!" Beneath Chin's

delicate shoulders up sprang a pair of glorious breasts, each of them easily a handful even in Shinji's large paws. They were crowned with large tan aureoles and thick brown nipples. The tits bounced a bit in the aftermath of their sudden exposure.

Shinji's cock returned from its frightened flaccidity to a state of increasing rigid interest.

Shinji thought he saw Chin faintly smile at their reaction. S/he continued to disrobe, but slowed down slightly. S/he carelessly kicked off the white tennis shoes and placed hir hand lightly on the chrome belt buckle. Chin slyly gazed up from hir downcast face to see Tanaka leaning forward and Shinji's trousers beginning to tent. Ms. Tanaka, cheeks visibly flushing, fumbled at the jacket buttons at her throat. Shinji watched her with a careful sidelong glance, as her jacket fell open, revealing a cream-colored silk camisole. Knowing her business dealings it was, most probably, real silk. She wore no bra. Fearing that he might be caught looking, Shinji looked back to Chin. The belt was undone, hanging limply from the loops of the black denim. Shinji, on the other hand, was no longer hanging limply. Pale long Chinese fingers toyed with the zipper. Chin was definitely smiling.

With urgency mixed with nervous laughter Ms. Tanaka said, "Come on now. Don't dawdle! Do you want our stamp of approval or not?"

"As you wish," said Chin quietly and slowly lowering the silver zipper. Straight black pubic hair, silky and wispy, peeked out from between the zipper teeth. Nothing yet. Shinji wondered if Chin wasn't simply a dyke with some gender complex. Then Chin dropped the black jeans to hir ankle.

Ms. Tanaka and Shinji gasped.

Between Chin's pale thighs, sprouting from the base of the faint field of pube hair, hung an uncut cock of well over 17-cm. Before their very eyes, the cock began to thicken and rise up slightly.

Ms. Tanaka and Shinji looked at one another in utter shock. Shinji shifted on his feet behind the desk, trying to move his crammed dick into a less painful position without obviously grabbing at it.

Chin stepped out of the jeans and stood before them. Without a word s/he sat back down on the metal chair, leaned back, spread hir legs and grabbed hir cock with hir left hand. S/he stroked it a couple of times, pulling the foreskin back, letting its moist head swell out of its hiding place. S/he leaned back further, pulling hir cock up to hir

belly. Beneath her hard cock, now a magnificent 20 cm, were two small ball sacs, lying a bit wide. From between the balls the skin changed into delicate folds, splitting aside, into full undulating cunt lips. Beneath it lay the small pink opening of hir asshole. S/he didn't simply possess an enlarged clit or vestigial labia; s/he was fully operational as man and woman in one body.

Chin moaned, eyes closed, to another full stroke on hir hard cock. S/he slowly opened them and looked the other two dead-on.

"Now, do you see?" Chin alternately hissed and groaned each word.

"Do you see why I'm such a freak? Now do you see why Singapore Inc. and my father want me butchered? With so much capacity for pleasure, why the hell would I want to get lopped? Tell me why I'd want to be just a plain man or a woman?"

"Does it all... I mean can you..." Shinji stammered.

"I think you're looking for the phrase 'fully functional.' And yes, I am." Chin raised one of hir eyebrows defiantly. "I've got a G-spot and a prostate, just where The Maker wanted me to have it." All the while s/he kept stroking the thick cock, enjoying the pleasure of hir own touch and the officers' stunned silence, arousal, and agitation.

Ms. Tanaka slid off the edge of the desk and stepped towards Chin. She stared at Chin's crotch with wide-eyed amazement. Without a word, without any courtesy or formality, she reached out and wrapped her tiny hand around Chin's cock. Chin grinned again and did not move away or remove her hand. Instead, s/he wrapped hir right hand around Ms. Tanaka's grip and forced her hand slowly down the length of the veined cock and up again, all the way to the glistening head. S/he did not let go. Ms. Tanaka did not pull away. Shinji grabbed his aching dick through his trousers and squeezed it as hard as he could. He ached harder but it felt good. His balls tightened. His breath quickened.

With her free hand, Ms. Tanaka unfastened her trousers, slipped them off her trim legs and kicked them aside. She stood holding Chin's cock in her black heel-shod legs, cream-colored lace panties and silk camisole showing the hard nipples. Shinji slid off his cumbersome jacket and undershirt and stepped around to the front of the massive desk. Ms. Tanaka's free hand reached out and caressed Chin's breast, stroking it with a fingertip then cupping it. Her tiny hand explored the breasts while holding the cock, as if to make sure that

they were really there. Shinji opened his fly and wrestled his now rigid cock out from its tight-briefed trap. Ms. Tanaka let her hand drop from the exploration of Chin's breasts, moving eagerly down and past the well-gripped cock. Just beneath the weird cleft formed by hir balls, her fingers began to stroke the edges of the outer lips up and down. Her fingers brushed the fleshy lips, naked of hair and utterly smooth. Her fingertips dipped between the folds and undulated in the pale pinkness. Her eyes were glued to Chin's cock and cunt. Shinji's eyes were glued to her hand as he slowly began to stroke his own dick.

Chin reached out with hir free hand and hooked a forefinger into the waistband of Ms. Tanaka's panties. She moved slightly closer. S/he slid off the panties as Ms. Tanaka danced out of them, all the while Ms. Tanaka never missed a beat in stroking hir cunt and cock. Chin's hand moved between her thighs and played in Ms. Tanaka's moist darkness, just beyond Shinji's sight line. Shinji moved behind Ms. Tanaka, kicked off his boots, ditched his trousers, briefs, and socks in one clumsy lump and sat down on the floor between her legs for a better view, his rock-hard cock firmly in his sweating grip.

Ms. Tanaka's shapely legs gloriously framed and filled his entire field of vision and existence. Her petite frame towered over him. The soft orbs of her ass hovered over his head, just beyond licking distance. The small of her back arched gracefully above that. Just a few centimeters from his eyes, her cunt spread open like a bursting, over-ripe red plum—plundered by pale probing fingers and oozing sticky sweet nectar. He wanted to reach out. He wanted to eat her out, but somehow, he just couldn't. He was too afraid to move and risk distracting her, in the fear that this lustfully glorious moment would come to an end. Chin's fingers fucked deeper and deeper into Ms. Tanaka. Shinji wanted to be Chin. Shinji desperately wanted to be in Chin's skin fucking Ms. Tanaka.

The entangled fingers loosened from Chin's engorged cock. Chin pulled hir wet fingers out from deep within Ms. Tanaka and sucked on them greedily. Tanaka, breathing heavily, leaned on Chin's shoulders and straddled one leg over the chair and then the other. She stood straddling just above Chin's cock, balancing on the toes of her pumps and hands on hir shoulders. Bending her legs, she maneuvered her cunt just barely onto the cock. Slowly and gingerly she lowered herself down onto Chin, very slowly circling her ass, screwing herself

Midori

onto the throbbing third-sex cock. Chin groped under Tanaka's camisole, pushing it up, exposing small breasts with painfully hard nipples. Chin sucked on one and then the other, causing Tanaka to throw her head back, moaning loudly. Her hair began to uncoil, trailing down her naked, arching back. The camisole floated down to the concrete. Chin's hands grasped Tanaka's ass and the long fingers dug into pearl white flesh as she fully impaled herself to the balls. Grasping her hips and ass, Chin moved her little body slowly back and forth, hir thigh muscles tightening and releasing in time to the thrusts.

Mesmerized, Shinji watched, matching the pulls on his own dick to the pace of the two fucking.

Between moans, Chin looked over Tanaka's rolling shoulder to Shinji and grinned.

Tanaka continued to groan and grind into Chin, moving with greater determination. Chin's arms wrapped around Tanaka's small waist, embraced her more tightly into hir body, then suddenly stood up, with Tanaka fully penetrated and caught on the limb of Chin's cock. Chin stepped forward, bent and gently lay Tanaka on the enormous desk, cock still firmly planted deep in her cunt. Tea cups, forms, and palm scanners clattered onto the floor as Tanaka's arm splayed out. She reached for the edge of the desk, grasped and pull herself harder onto Chin and kept grinding. Their breasts, nipples hard, pressed into one another. Tanaka curled up from the waist and grabbed one of Chin's breasts and sucked at it hard. Chin groaned and thrust in another deep stroke.

From his spot on the floor Shinji could see everything. He could see Chin's dick sliding in and out of Tanaka's wet, swollen cunt lips. He saw Tanaka's legs wrapped tightly around Chin's waist, black high heels digging into hir ass, driving her harder into her. He could see Chin's balls, small and tight to hir body, with hir gloriously odd pussy gaping open with each thrust. Tanaka's cunt dropped down Chin's cock, down between the balls and into hir cunt, mixing with the hermaphrodite's juices.

From behind hir, Shinji knelt up into Chin's crotch. A trickle of mixed juices, white and thick, began to flow down Chin's inner thigh. Decorum utterly abandoned, he caressed Chin's smooth, muscled legs. He kissed hir inner thigh and let the tongue slide up towards the strange opening. The scent of salt, sour and musk filled his nostrils,

strangely familiar yet alien. S/he smelled of primal sex, of all and any sex. The wet slapping sound of the two fucking filled his head. He licked his way up to the dripping juice, to taste Tanaka, and Chin, for the first time. Shinji felt Chin's hand on the back of his head, caressing and coiling his hair into hir fingers. Then s/he simply pulled his head, face first and hard, into her cunt. Obeying the insistent hand, Shinji licked at Chin's pulsing cunt, with a profound new thirst. Chin's pussy muscles contracted around Shinji's tongue and guttural sounds came from deep within hir. Chin's knees buckled a bit which pressed hir cunt harder onto Shinji's tongue fucking. Cream flowed into Shinji's mouth and the Chinese came on his face. A breath or two of a pause and Chin continued fucking the moaning Tanaka, who at that very moment came with such a shudder and scream that she knocked Shinji back to the floor.

Chin pulled halfway out of Tanaka and moved her legs over, smoothly turning her around to face down. Her breasts pressed hard into the rigid table. Chin then growled and thrust fully into her again.

Shinji rose from his ass and dove in further between them. He opened his lips and took the hermaphrodite's balls into his mouth, burying his nose right into where their sex joined, all sloppy and wet. He sucked eagerly while rubbing Tanaka's clit with his nose. Her pussy and clit were so deliciously soft and sweet and he wanted to swallow her whole. He was high on her. She cried animal sounds of pleasure. His tongue flew wildly onto balls, cock, cunt and clit. His face bathed in juices and smells, he licked, sucked and pressed in until his back could stretch no more. He collapsed to the ground and scurried to his feet.

He stood, the other two still locked in the table-rocking embrace. Her jet hair spread out on the table and her face flushed with pleasure and sweat, Ms. Tanaka was so open and ripe; he wanted to fuck her desperately. Still, awed and struck by disbelief, he could not move in on them. He stood there, staring at them frozen in desire and amazement. A hard throb and the crawling of pre-come down this cock woke him from his lust-filled daze. He moved behind Chin, now screwing Tanaka with the easy pace of voluptuous fornication.

Shinji stood behind Chin's frame, muscled yet soft, angled yet smooth, both male and female. S/he looked back over hir shoulder and grinned a sex-stoned grin at him. He could clearly see Tanaka's orgasmic face and naked breast beyond the hermaphrodite. Shinji held

Midori

Chin's hips, bent his knees and slid his prick between hir thighs. The head halted a moment at Chin's asshole, pressing just a bit, as he thought of how sweetly tight hir ass must be.

He slid his head forward and it nestled in a crevasse of fleshy warm moisture, opening and pulsing. Looking over Chin's shoulders Shinji lost himself in the flush of Tanaka's cheeks. She looked up, meeting his gaze. His brain boiled, his head swooned, the blood surged and he thrust through Chin. His cock bathed in a tight undulating pussy flesh, he stared at her and devoured her with his eyes as he pumped Chin hard. Chin howled in ecstasy. Shinji fucked hir unrelentingly; he fucked Tanaka right through Chin. The pressure mounted in his gut. Her eyes closed, her head shook, her body arched up and she screamed "Shinji, come!"

He burst into Chin at her command with all his strength. Pouring all his hot come into hir, he felt hir cunt tighten and body rock. Chin shuddered and came pounding into Tanaka.

"Welcome to Nippon, Mr. ... or is that Ms. Chin?" Ms. Tanaka spoke calmly. "Here are your documents for the conditional work visa." She was her usual officious and uniformed self, except for her hair, messily put back into place... and the flush in her cheeks.

"Thank you," Chin said, trying to appear as cool as possible, though s/he reeked of sex. Shinji simply sat unmoving and unspeaking, not entirely sure what he could do or say.

Ms Tanaka looked over the monitor on the freshly reorganized desk to Chin and a faint smile crossed her face. The flush seemed to bloom again. "You do understand, of course, that your conditional visa requires you to renew within twelve months. We suggest that you seek our office again as we are most familiar with your, um, unique case. I'm sure we'll be able to expedite your visa for your valuable contribution to our nation and our partriotic morale."

"I'll see you in a year. Thank you for all your considerations." Chin rose from the chair, hesitated a bit as if to ask for something else, then thought otherwise. S/he clutched the documents, bowed lightly from the waist and walked out the heavy door.

MASTER HAN'S DAUGHTER
PART TWO

I have the address, but I walk the streets at random. Still feeling jacked up on all the info Jiro's downloaded into me, I decide that I need to blow a few kilocals of energy before I can focus on a plan of action. I turn down the alley off the Ichome arcade and slip into a familiar alcoved entrance to a garishly lit pink building. On the building's side is the ever-subtle, 200 centimeter tall, blue neon sign spelling out "HaPPi LUV" next to a giant photo of a cherubic girl with ungodly huge tits. The fact that there's actually a branch of our ever more dower and stuffy government that specializes in pink, neon and faux flesh sex always amuses me. I press my yenID card on the door pad and it slides open with a cloyingly sweet and enthusiastic electronic girl voice greeting me "Irashaimase!" (If I were running this joint, I'd gag that computer first.)

The lobby is just as tawdry—dark smoked mirrors, pink tiles, blue neon, pink vinyl couches, and chrome tables. Scattered on the tables are ratty old porn magazines and a few faux leather binders with the stats on the girls in this bordello. "Girls" is one way to refer to the creatures featured in the binders with the list of services provided, but trained blow-up dolls would be a more apt description. Borne of synthflesh, lube ducts, a robotic musculoskeletal system, and a nanochip brain loaded with a few hundred standard sex scripts, these dolls are Dr. Frankenstein's sex monsters. Who would have figured that the first generation of cyberdroids would be whores? Move over C3PO, unless you can give me a blowjob.

I don't need to look at the catalog of talents plugged in here. Since there's no name on the "New Pleasure Girls" board, I already know my selection. I don't much mind fucking smart plastic. They're a

Midori

helluva lot cheaper than the mutation-free organic femme whores and much safer than the freaks in the alleys. I do have some standards, after all.

The usual hunchbacked hag doesn't occupy the service desk. Instead a familiar face sits behind the counter, reading some thick tome of a Russian novel. "Hey, Ari," I call to the man with the salt and pepper crew cut. "What are you doing here?" Battle-weary gray eyes look up. The weathered face shifts from a disgruntled annoyance to a look of pleasant recognition as the scars on his face creep aside to make room for a broad grin.

"Substitute rubber-duckie wrangling. I guess I don't need to ask you what you're here for," quipped my old drinking buddy. An ex-pat Anglo, it wasn't hard to tell that he was a veteran of the Frontiers War even without his trademark black wool and leather field jacket, battered yet somehow still dignified.

After some time shooting the breeze, we get down to business. I'm still horny for a little bounce on the synthflesh. Ari punches in the pass sequence to my toy's abode. "It's a good thing that the recent tech glitches with the new models have been cleared up. It wasn't at all good for business to have all those accidental dismemberments..." grumbles Ari.

Somehow I still manage to keep it up. Thanks a lot for that info, buddy.

Mariko resides in room number 43. It's a different universe in here. The moment I step in, the plastic door closes behind me and blends into the wall of paper doors. The entire room is in the old fashioned Japanese motif of tatami mats, polished bare wood and paper screen doors. There's a simple and elegant flower arrangement in an alcove on my right. These too are synthetic. To my left is a low wooden dresser with a mirror. Mariko sits before the mirror, painting red onto her small lips with a bamboo brush. The skin of her face and neck are painted white. The glossy black hair is piled up into a "Momoware," the split peach style popular back in the 19th Century. Her kimono is simple tonight with a navy frock offset by a gold and orange obi. I remove my shoes and place them at the entryway. I like to observe these ancient customs sometimes.

"My lord, you are early tonight. I've not finished dressing for you." She doesn't miss a beat. It's as if she's my woman and I come home to her every night. I don't mind that there's a bit of reverb to

her voice tech tonight. I think she needs a tune-up. I'm low on yen so I'll have to skip the sake. I stride up to her and kneel behind her. I slide my arms around her and kiss the nape of her neck. I think I saw a soldier do this to his geisha in some old flick. I pull her up roughly and try to kiss her on her mouth. She blushes and protests formulaically while allowing me to smear her lip-paint across her white powdered face. I let one hand slide behind her and find the free end of the obi. Mariko dresses in the full traditional style with the wrap around obi. None of this clip-on business. I love to do what I've seen in all those old flicks. I take the end of the obi and yank on it. The intricate bow comes undone and I pull the rest of it off of her, watching her totter and twirl like a boy's spinning top. She falls to the floor with her kimono undone and legs akimbo. Soft, white, inner-thigh flesh shows invitingly. My cock swells.

Taking one of her thin sash cords, I swiftly tie her wrists behind her back. I tie her ankles together and yank her legs back, tying her ankles to her wrists. These dolls sure can take a lot of forcible bending. "Ahhnnn… no!" She moans. As she tugs and struggles against her bondage, her kimono slips aside and her knees fall apart, showing her hairless plastic cunt. She continues to struggle as I stand, watching her torment. I whip out my cock and straddle her chest. Grabbing my cock firmly with my left hand I start to stroke it. She turns her head away in shame. "No, my lord…" A sharp cracking sound fills the room as I slap her hard across her cheek with my right hand.

"Don't you go resisting your Lord and Master. Is my dick a thing of shame?"

"No, sir, I'm sorry sir."

"That's better. Let's make sure you've learned a thing or two!" I slap her across her face a couple more times for good measure. God, this feels good. Then I take my cock and slap her around with my stiff rod. Her head swings from side to side and her mouth falls open. Unceremoniously I stuff my cock down her throat. (I try not to remember Ari's comments on recent accidents….) Her toothless rubber mouth snaps shut and begins to swallow and pump my cock like a milking machine. Her wet mouth slobbers and gobbles my cock hungrily. I pump her face furiously. Grabbing the back of her head, I pull her mouth deeper onto my dick. These models don't come with gag reflexes; instead her mouth cavity fills with warm, gooey fluid and starts to vibrate.

Midori

She's programmed to get me off quickly tonight since I don't have much left on my plastic. Her efforts are productive. My hips are thrusting fiercely into the mechanized sucking-machine mouth; I'm moaning loudly as I stuff and prod deeper and faster into her. The pressure builds up behind my balls and I can't hold back anymore. I slam her head repeatedly onto my cock and shoot my come hard down her throat. I feel a long tightening, sucking feeling as Mariko squeezes out every gram of jizz with her latest vacuum technology, not letting me go until I'm dry.

I pull out and there's a silver trail of come and lube trickling down the side of her face. Her face forms an almost wicked grin, but she's frozen, doesn't move or say anything. I must be at the end of my session. I police up my limp tool, dress, kick my shoes back on and leave the room with Mariko still bound and motionless. Fucking and ditching the dame is drama-free and easy when they're synthetic. I step out of the tatami room and my fantasy lordship, back into the painfully real world of pink buzzing neon and the wafting aroma of piss, jism and chlorine.

I buy two beers from the vending machine in the hallway. Leaving one for Ari, who grins a goodbye at me, I head out to the dark greasy streets with my cold beer in hand. I take some powdered courage and head off to the address that Jiro gave me.

At the edge of the financial district I enter a nondescript office. A prim little man in glasses greets me, and hands over a form for me to fill out. He doesn't even ask me why I'm here. Why should he? As far as I can see there are at least 200 other fools like me in the large classroom, filling out forms and dreaming of a better-doped life. The process is as dry as being conscripted: forms, a physical, biopsy from the stomach lining, EEG, and a sperm sample. I suppose I am being conscripted to a tour of duty. If I make it past this step, I'm off to the battlefield of Miss Mai's bedchamber.

Two hours later I'm spit out the door like a used wad of tissue.

Two weeks pass, I hear nothing. A month passes and still I hear nothing. From time to time I press Jiro for information, but he's just a loser pusher so he knows nothing. I just waste more money on food and beer. Finally after three months or so, when I've almost forgotten about the whole thing and the fantasies of opiated bliss have faded far behind more Hong Kong Honeys and other Sofias, an old fashioned red envelope is slipped under my door.

Tearing open this arcane data file, I find a piece of yellowed paper, nothing like I've ever felt before, thick and warm to the touch, very organic and surreal. Black ink flows down in a dancing, ancient script style, almost illegible in its hand-wrought brush strokes. Damn, Master Han is so full-density retro that I almost can't read it. It's even in full and proper Nihongo, not Canto-Nihongo, my dialect, the trade tongue of ShinEdo.

> The Honourable Master Han requests the pleasure of your compa-
> ny to meet with his beloved daughter, Miss Mai on the auspicious
> day of.......

A flake of gold foil flies gently off the red chop mark and floats delicately in the foul, rancid container air, as if waiting for my decision.

I'm seriously creeped out and I'm not sure why.

A chill crawls up my spine. I hear a crack in my head and realize that my life just suddenly dropped down a hole and landed in the sharp-clawed hand of a woman who doesn't give a damn about me. Yakuza are gentle and reasonable compared to what a dame can do to a man's brains and nads, never mind what this bitch might do to my flesh if I don't bang her right.

I slam open the door to see who the messenger was but they're long gone down the gangways and scaffolding. Sneaky bastard. The genteel wording of the letter is a load of crap. I know that I've got no choice but to follow the instructions to the letter. If I back out, Master Han will send some goons out with a surgeon and cut my balls off for the seed. Either I will survive the profuse bleeding and live nad free, or I'll just bleed to death on the spot where they cut me up. So, I've got 9 days, 6 hours and 37 minutes before I report for this duty.

What was I thinking when I applied for the screening?

I remind myself of the upside of this deal and why I signed up in the first place. Unlimited chems. Getting out of this god-forsaken hellhole. Life of leisure. Access to unimaginable wealth. Poontang for the picking. Then there is the whole idea of finally getting a piece of Mai, the finest bitch meat anywhere, and maybe, just maybe making her beg for more. My tool stirs just thinking about dipping into her.

My head is frozen in fear, yet my cock boils up stiff. I reach system overload and pace wildly. Man, I have got to get a hold of myself.

Midori

So I do, literally. I'm getting a hold of my dick and getting some relief. Slapping on the visorscreen, neurosheath and all the wetware hook-ups I have to as many nerve sites as I can manage, I nav quickly to where I need to be, Hydra Man. This login will drain me of a big wad of yen like cutting an artery, but either I'm about to be rich beyond belief or dead, so who cares?

Hydra Man's got the tops of top interface programs for quantum hentai flesh-to-flesh hook up. It's a simple fail-safe concept. No net ho's here. It's all members, getting off on other members in full body link-ups from around globe, any time, any place. Either you're a Hydra or a Doll. I select a low-level Hydra with sixteen heads including four controlling heads, basic features, and limited avatar longevity. I don't have the tech and software needed for the full joyride. The uber-luxo package requires a neuro gel immersion tank and a spinal port or two plus some medical staffers on stand-by to reboot your bios, just in case. Now, that's dedication to your pleasure! Unfortunately I am just a code creep and the best I can do is stolen trodes and crappy, pirated sheaths made in Terra Nova America. The Dolls come in multi-gender human forms. I select the all XX options, deleting out the XYs, XXYs and other 'sapien varietals I just can't deal with. T&A is what I need and lots of it. Quantity: four. That's four heads per chick, which ought to be good enough for now. One last thing—a couple of Dreamer tablets with a ghetto sake chaser. Just enough to melt the walls of disbelief.

Hydra Man patches me through pretty quickly, which is good, because I'm so worked up that otherwise I'd to hurt someone or torch my place. The admin chatter on my visor fades to black and my nerves tingle as I Hydra-ize. The pills kick in and I feel a bit motion sick. Eventually the ringing in my ears subsides and I stabilize. Now I'm floating directionless in black space.

I turn my head and see my other heads. Which is weird because I'm seeing myself from inside the other control heads, as well, seeing myself looking back at me. I'm a huge green-scaled blob with sixteen thick, serpentine necks, topped with bulbous penetration heads. Twelve heads act and feel more like my limbs while four heads behave much like my actual head, seeing, thinking and controlling. I can see from all four control heads with images staggered and over-laid across my field of vision. I have to re-learn to focus on the center of the visual feed from each eye group and control head to let the others fade

back. The frames bounce around and leap somewhat randomly until I get a grip on my focus. I feel input from all 16 heads feeding into all my trodes and sensations overlap on my skin.

I wiggle my body and all the heads sway, some bumping into each other. This hurts like a small thunderclap in my brain. My eyes cross, my head spins, and I get a bit queasy from the multi-headed sensory disorientation. It's been too long since I've Hydraed so it's taking a while to get used to the tentacles. I close my eyes, shut out the visuals for a while, and just play with the kinetic feedback loop. Gradually the controls come back to my muscles. I open my eyes and manage to ditch the tentacle sickness, a common malaise for the hentai enthusiasts. Once oriented to the new sights and sensations, I opt in for Interaction with one flick of a rubbery arm. Thank goodness for the Free Orientation Period; it's a nice customer service feature with this site. Otherwise I'd be eating up yen credits while upchucking my inner squid.

In the murky gray darkness four figures glow, fuzz, and slowly come into focus. A rainbow array of female flesh zooms in toward me. The first avatar babe to approach my wriggling welcome is head-to-toe cobalt blue with long purple filament hair floating around her head. Other than the purple hair she is entirely smooth as her nakedness twists towards me. Enormous tits, each larger than her head and tipped with dark purple nipples, bob obscenely, leading her body toward my swelling tentacles. Her huge anime eyes blink glossily, filled with extra star effects shooting out and forming sparkly rainbow auras around her. Two of my tentacles wrap around her soft tits, twisting and squeezing, bringing her in. I feel soft flesh all along my human arms. Her tits throb in my tentacles and her body arches back. Flailing legs float up toward me, splitting open to show a deep purple cunt. A third tentacle jabs into her and she squirts and splatters over me. My own cock feels juiced. I hear her moan.

Somewhere on this planet a woman is getting off on getting tentacle-raped.

Overlaid on the vision of the tentacle impaled purple cunt I see another chick through the eyes of one of my other control heads. A pale doll of a Lolita Goth model floats and flirts past me, flaunting many-layered white lace petticoats and torn fishnet-covered legs. Still hard-fucking the purple bitch with three tentacles, I reach for the Lolita Doll. One of my tentacles wraps around her waist and coils her

Midori

in while another tentacle slides into the fishnet opening and crawls up her legs, ripping the fishnets further. Dead Goth eyes rimmed in smudged black eyeliner look back at me. She opens her mouth into a low moan as the tip my tentacle parts her cunt lips.

Her fangs grow long. Fuck, she's a vampyr freak Goth! I decide against face-raping her. Instead I squeeze her tighter and tighter around her waist and lock the suction cup of another tentacle onto her pierced clit to see how loud I can make her scream. Her fanged jaws snap hungrily on thin air. Two other tentacles tear at her corset, releasing budding girl breasts. I cap them with big suction cups, suck and twist hard. A black crucifix floats around her neck.

My field of vision undulates a bit as the eyes of the third control head began feeding signals to me. Now on top of the purple cunt and the creepy little Goth chick comes a brown body with luscious full tits covered in tawny fur. Fur? Yeah, fur. She's got a cartoon fox head, a bushy red-brown tail and the hands and feet of an animal—probably a fox. Other then being fur-covered, her torso is that of a ripe and ready chick. It's a little weird but I go for it anyway, grab her by the tail and pull it up. She's got a sweet, human cunt and asshole. So with a tentacle for each hole, I pillage her ass and her cunt deep and hard. She wails weirdly like a mix of a dog and a cat. Whatever. Her holes are tight and that's all that matters. Somewhere there's a chick in a fox suit embedded with trodes against her skin and screaming to my fucking. 'Sall right, I suppose.

The blue bitch is grabbing my tentacle and pulling it harder into her hole. I feel her squeezing hard on my cock.

My cock throbs wildly but I want my fourth before I spew, so I look around with the last control head. A form covered in blue cloth floats towards me. Where the face should be is a blue mesh screen. It's a chick in a burqa, for god's sake. This is a new twist even for me. Is this a costume, a fetish, or the actual image of the real woman who's hooked in? I look around for someone else, maybe a nun or a school-girl or one of those water nymph thingies, but no dice. She's the one I'm stuck with.

I reach out with a tentacle and grab one ankle and watch her fall toward my twisting, writhing snake's nest. Her skin is smooth, supple and highly rendered—a high-end account holder. A free feeler swims towards her, grabs the edge of the veil and violently rips it off her. Underneath is an olive-skinned woman with gleaming black thigh

boots, a hairless cunt, melon-sized tits and a red-painted mouth opened for the fucking. Her face other than the mouth is entirely smooth, void of nose or eyes. In fact, the mouth covers almost her entire face. A thin area of skin surrounds the painted lips and lapping tongue. Beyond that flows long, thick normal black hair.

My stomach turns a bit as I stare at the gaping mouth-hole and I almost lose the grip on her ankle. All my tentacles shiver. But my faithful cock never loses its hard-on.

A bit agitated by this featureless sex-doll, I let my other tendrils twist and fuck the other three women even harder. I smash the Goth doll into the blue bitch and let her bite down on the long cobalt neck. I hear the skin rip. Blue chick gurgles and moans. As the Goth doll drinks, my tentacle around her waist feels her stomach pulse in time with her virtual blood gulping.

This is a weird turn, even for Hydraland.

My fourth control head focuses on the eyeless mouth. I let one of my tentacles get as thick as possible and slam it in. She gulps like she is going to gobble me up. Quickly I take three other feelers and stuff them between her legs-one up her ass and two into her cunt. With the fat wriggly member in her face I can avoid looking at her bizarre blank head.

My head swims in layers of images. Fox heads, dead eyes, cunts, legs, purple tits, furry tits, a vast gaping mouth, asses, pulsing holes. While four heads and sixteen members grab, fuck, twist, squeeze, fondle, and flail in the murky darkness, my human limbs twitch and contort in the cluttered res box. My mouth dries and I gulp at the air while I ravage the four women, or they ravage me, or something like that. The neurosheath contracts wildly around my prick. The heat builds up in my balls. My eyes roll back into my head as the images grab at me harder. I buck in my bunk and my tentacles quiver and shoot an ocean's load of jizz into outer space.

I log off before having to look at the women again and ignore the yen tally. Master Han crosses my mind. I feel sick. Things go dark and I pass out, with all the apparatus still hanging off me, tangled in strands of drying come.

A pounding headache and leg cramps wake me from my happy oblivion. A vague sense of urgency batters my foggy mind. There was something I had to do and it seemed important.

Midori

With a start I jerk up and remember the pending meeting with Miss Mai and the Old Master. I desperately need a survival strategy. I peel off the trodes, neuros and dried come, splash my face with some water, and I am ready to hunt for some clues to my survival.

I snoop the net for any reference to her previous suitors and find plenty. Many are shouts and proclamations of great prowess, bragging by the contenders themselves, like matadors flaunting their machismo before facing the bull. These are the final statements I can find from any of them. They could have simply gone into hiding after abysmal humiliation at the hands of Mai-but somehow I doubt that.

Pretty soon I come across a gossipy fan society of Miss Mai's morbid little sycophants. Among the costume role players dressed as Mai (Dead Mai, High Mai, 'Tween Sailor Mai, Drag Mai), Mai hair collectors, sighting reporters, and love letters offering ritual suicide is the unofficial list of previous suitors and a betting pool on each's survival. Thankfully my name isn't there. Yet. The list isn't small either. Like some sick cockfighting circuit, all the men's stats, methods, and speculated duration of survival are posted along with gleeful bantering. I mine it for info while numbing my mounting fear with cheap rotgut booze.

These losers—losers like me but now dead losers—have tried just about everything with Miss Mai to keep her happy. RockHard pills, bionic implants, freaky machines (it says that she hates those and she'll turn them on the men), bullying, beatings, groveling, psitronic music, and even prick plastic surgery involving spliced animal cocks. All have failed miserably, according to the gossip ring.

I am fucked.

I can't afford most of the crap those guys tried. What am I supposed to do?

Hm. The gamut of failed attempts does have one thing missing—the Old Ways.

With nothing to lose, I head out into the buzzing early evening of res tower land. Dodging all my usual haunts and their temptations, I head to one of the bridges where I catch a taxi. It floats me to the decrepit entry gate of Asakusa and dumps me there for a pretty penny. They hate bringing fares to this part of Old Edo. I'm not much too happy to walk between the decaying wood-and-stucco buildings either, but

I know the things I want and the man I need are here. It helps to have strange friends in rotten places.

The narrow streets twist, split and slither deep into the dilapidated district. The teetering balconies lean toward one another, closing me in this living tomb of putrid antiquity. Laundry hangs limply from lines between houses like death flags. The bitter smell of evening meals, charred flesh, grilled scales and gas fire wafts around and clings to me like grease. Foul-smelling old women and stoop-backed geezers stare suspiciously at me from doorways and balconies. It's been too many years since I've been in this quarter. Losing my way more times then I care to, I finally find myself in front of a small storefront. The shop name on the sun-faded awning long since disappeared. Hand scribbled signs on the scum-covered window seem to post prices and names of the items inside, but they are useless to me since I can't read old Cantonese or Hangul.

I part the noren, a pair of old-fashioned Japanese curtains, and walk into the tiny, dark shop. The musty smell of old dried plants and pungent medicinal liquids overwhelms me. There is barely enough room for me to turn around in the storefront crammed with boxes, baskets and jugs of all sorts. As my eyes adjust to the drab, shadowy confines, I see every inch of the space crammed with more jars and concoctions. The wall is covered with cubicles full of strangely marked tins. A forest of hanging dried herbs obliterates the ceiling. From somewhere behind this chaos oozes a dark figure.

"Ahn nyuhng ha say yo" says a surprisingly melodic male voice. The man emerging from behind the basket of dried lizards is small but plump with ruddy cheeks and a genuine smile rarely seen over on ShinEdo isle. Doctor Lee wears a simple black tunic and pants. His gray hair chaotically falls down to his shoulder.

"Hey old man. Long time no see," I say in Canto-Nihongo. He squints, looking me over with a frown and then the smile returns, even bigger. "Yah, meng kong ah! It's you, little brat! I figured you'd be dead from all your vices by now." Well, he has me pretty well pegged.

"I will be if I can't solve a problem I've got. Figured you'd be just the wizard for this." I explain the situation to the good herbalist, leaving out the bit about aiming for the endless supply of Master Han's fine chems. Doc Lee fills in those blanks, I'm sure. He clucks and sighs as I explain. When I finally finish he stares at me in silence, as if to say,

Midori

"Have you lost your mind to try such foolishness?"

He's right, but I can't back out now.

Doc Lee signals me to sit down. Obediently I sit on a large barrel of some ground-up animal part. He asks many questions about Miss Mai, the date and time of the meeting, and myriad other odd questions. After I answer as best I can, he disappears into the back room. This is going to take a while. I hear Korean mutterings and the clattering of containers. The place begins to stink worse. I wait.

Eventually the old Doctor reemerges with a small metal container, the size of a pillbox. I reach for it but he won't hand it to me. "Are you sure you want to do this?" he says.

"Well, my life's on the line, so yeah, I'm damned sure."

He hands the container over and I open it. The stench is obnoxious, like rotten anchovies and manure. It looks like it too. "You must apply this thoroughly onto her cervix and the soles of her feet. This is good for one application. You must use all of it."

I can't imagine how I am going to get this reeking gunk near her, much less shove it up her cunt.

The Doc continues. "At first she'll feel a searing pain. She will not like it." That's probably an understatement; I know the old man's style. "Soon the painful writhing will turn into the torments of deepest pleasures." This part gives me some hope. "This condition will last for a night to a night, a day and another night. This will depend on her susceptibility." Even better. "During her writhing, you must not enter her, or your wood will be covered with the ointment. This would cause madness in you. This blend is for the yin, not the yang."

When he tells me the price, I just about fall off the barrel. After some haggling, I pay him what is still an astronomical sum. I remind myself of the futility of the yen to a man in my fucked-up position.

The next several days pass in a comforting drunken haze, punctuated only by the dull agony of work and occasional terrifying moments of rational awareness, brought on by lack of chems or booze.

The Doc's special metal container sits on a shelf near my bed, waiting, staring at me and mocking me.

When the appointed day comes I just sit in my res box and wait, trying to sober up and be somewhat presentable. My hands are cramped from gripping the container too hard and too long.

The four goons in dark suits at my door are enormous with heavy-

lidded Continental features. They appear unaltered, but I'm sure that they've been augmented to suit the Master's needs. God knows what those guys are capable of. They aren't much for smiling but they are polite and traditional. They bow deeply and announce their "invitation" to join the Master. A somber but expensive palanquin floats behind them. I climb in and gawk at the luxury of the ride. The cushions are real silk and the furnishings are real teak. The walls are some sort of crazy transparent silk-like fabric that doubles as view screens. Elegant, tiny Chinese nibbles and tea wait for me, shrouded in savory steam.

Everything is shrouded around Master Han.

On the silk walls I watchethe ugliness of my 'hood pass by below as we float well above the squalor. The caravan speeds up and we shoot out of the city and head north toward the wooded mountain lands of Hokkaido. I've never seen the forests or old volcanoes. Here and there the remains of small, charred cities pock the landscape. My mouth gapes open and I gawk at the wild Nippon that I have never known.

As the caravan slows, the silk walls of my palanquin turn opaque and ancient fabric patterns dance and undulate across them. I am denied all access to where we are and what lies below us. We must be nearing Master Han's compound. The walls glow with a soft light and bathe the floating room in warm, amber colors. I feel oddly relaxed. There must be something to those glowing patterns in the walls.

The next couple of hours are a blur of strange ancient customs. One of the goons stands by me and tells me what to do. No one seems to expect me to know squat and no one gets in my face about it. Thank god.

In a great hall I am introduced to the Master, who sits on a stiff-backed teak chair flanked by a scholar's table and twisted midget tree. A scroll hangs from the wall behind him with scenery of mountains and brush-stroked poetry in an ancient illegible font. A small man of grave demeanor with graying hair and a wispy beard, he seems as still and ancient as the things around him. He invites me to sit nearby in an equally stiff but slightly less grandiose teak chair. He speaks softly about filial loyalty, the importance of duty, the duties of the groom and family to one another, the great Han family lineage and so on. It strikes me that Master Han really does intend to keep the groom in a state fit for their family. Is this really the brutal drug lord of the East? After much bowing, proclamation reading, formal interrogation of the groom-hopeful and tea drinking, I feel like I am in some bizarre

Midori

period movie. It is all just unreal. I just follow along and do as the old man and the goon tell me to.

The goon escorts me to yet another ancient room with a teak bath and giggling maidens. I didn't think giggling maidens existed in this day and age. Had I been in my right mind, I would have tried to grab or molest each of them. They bathe me in perfumed water and dress me in a stiff, black silk tunic and pants with red emblems. The goon puts a black cap on my head with tassels on it and hands the metal box back to me. No one has asked me about the metal box. I guess by now they are used to the applicants bringing things that give them an edge on the battlefield.

The ridiculous outfit now complete, the goon signals me to follow him. I board an open sedan with him and we fly across the vast compound to another building. He briefs me on the procedure. He will leave me at Miss Mai's bridal apartment. The doors will be locked for 24 hours. Tradition and formality is done with once the doors are locked and then it will be up to me to make her happy.

"At the end of 24 hours I will unlock the apartment. I will come and get you," he says. I'm sure he means to say "what's left of you."

The "apartment" is a whole fucking reproduction of a Chinese mansion. The huge doors with enormous "double happiness" markings open soundlessly on their own. Two candles burn brightly, one on each side of the entryway. Each candle stands two meters high with images of a bird and a dragon emblazoned on them. Beyond that, in the polished wood hall stands a canopied wood bed, larger then most res boxes. At the edge it, facing me, sits a figure in a red dress with her head draped in a bright red silk scarf. I can see delicate hands clasped modestly on her lap; the metal-capped claws glint in the candlelight.

There sits the falsely demure Miss Mai.

The goon bows deeply toward her, and then shoots me a wicked grin. Is it encouragement, pity, or mockery? The doors close silently behind me, followed by a loud series of metallic clicking. The dramatic sound enhancement is a nice touch of psych-out.

Then it is silent. Broken only by a giggle. Her giggle. I try not to whimper.

If I survive tonight, I'll get everything I've ever asked for... Life of luxury, all the dope I can do and most of all, escape from my squalid life.

From the journal of Zhao Zhiqiang, chief of protocol, Han Estate, Hokkaido

" Today the Young Master Quon visited this estate on the occasion of the Young Master's third birthday. Young Master had spent much time playing with his grandfather, Great Master Han, and his mother, Mistress Mai. Mistress Mai had flown in from her estate in Brunei for this occasion. After which Young Master was taken to see his Blood Father in the hospice on the grounds. I am happy to report that our recent installation of custom life support equipment was successfully child proof, as the Young Master crawled over his father. The Blood Father's health has been well. The estate is taking excellent care of him since the overdose. Great Master would not have it any other way. It is indeed a shame that the Blood Father was not warned of the potent power of the fresh Opium ball that Great Master offered him after the consummation with Mistress Mai. He fell into a deep vegetative state and has been in our care since then. It is our filial duty. We are certain, however, that he is happier now then before and he has all that he has wished for."

AUTHOR'S NOTES

All characters in this book are entirely fictional. Any resemblance to people in the author's life is purely coincidental. All acts of sexual depravity in this book are also purely speculative and fictional, not reflecting the opinions or fantasies of the author one bit.

Ok, so I lied.

Many of the characters are based on my friends and fellow evildoers. Some are combinations of several people I know. I may use their appearance, a sliver of their fantasy that I'm privy to, their sex style, or some part of their personal history or personality. Some are even lovers of mine, past and present. Many of these friends of mine know that I've turned them into loathsome characters in the filthy underworld of ShinEdo. The conversations usually go something like this...

> Midori: Hey, I'm writing a science fiction book with lots of filthy sex in it. It's set in a not-too-far-in-the-future Tokyo.
> Unsuspecting Friend: Cool.
> Midori: Can I turn you into a half-cat hooker character and then kill you off?
> Unsuspecting Friend: That's great! Make sure it's really nasty!
> Midori: OK, I'll send you a copy.

I have weird friends.

So you want to know who they are? Some of them I can tell you.

Midori

Authors Notes (vertical, left margin)

Ernest Greene, who at the time was the editor for Hustler's *Asian Fever* magazine, originally commissioned the short story "Master Han's Daughter" for the magazine. He asked me to write a science fiction story set in Asia, featuring some version of the "Real Doll" sex dolls and lots of nasty sex. It seemed only polite to have him make a cameo appearance as Ari, the old war veteran at the front desk of the state-run brothel. If you know Ernest, you can just hear him. I wrote that bit with his voice in mind. An alternative medicine guy out here on the Left Coast inspired the smiling Doc Lee, always there for a friend in need.

Miu the Cat? Her body and lanky gutter sexiness is from a model friend of mine. She rescues stray cats. Seemed appropriate.

"Kitsune Gumi" is packed full of my buddies. This story started out as a way to pass dull time between two friends. Many years ago, Michele Serchuk, a well-known photographer in New York, and I were walking back from a nightclub that turned out to be a complete dud. Well after closing time, we were walking across town on Houston Street on a hot, New York summer night, kicking back and forth a story of a better night than what we were really having. There's a woman in LA who's a real Kung Fu master and possibly the coolest woman I know, she's very much Chin. Also appearing in the story is a tall, blonde academic from the East Coast. She makes an appearance again in Full Moon Fever. There is a real-life Kenji, but he's much more humble and sweet then the fictional guy. Dex, ah, well Dex... she's a couple of lovers in my past put together. You see her again in "Aya's Blade." Shell's a computer gal I know.

Shinji's baseball connection in "Your Documents, Please" is a little gift to Cecilia Tan, who's a total baseball fanatic. Come to think of it, the cool-under pressure, smart and efficient Ms. Tanaka does seem a bit like Cecilia's evil twin.

It's not just the people that appear in my world. My favorite places and things shape this city in my head. The motorcycles in "Aya's Blade" are based on my Devoted One's pet metal-beasts. I tend to think of the area that the Kitsune Gumi hang out in as the Meat Packing District of New York, in a parallel universe. It's just not the same since it's gentrified. The gay leather bar in "Aya's Blade" is based on a real place. If you replace the red neon chevron over the door with a red neon spike, you have the Spike, a bar that once stood on the meat- and male-littered edge of the Meat Packing District.

Master

Thanks to all my nefarious friends and their lives of intrigue!

Sometimes, as I'm spinning a story I realize that I have to weave in tales near and dear to my heart, or that the characters are reincarnated from some other narrative. The mean streets of ShinEdo are not so unlike the bitter streets of the Industrial Revolution in Hans Christian Anderson's "Little Match Girl," who I have resurrected as "A Cat Named Miu." I got so into writing that story that after I finished it in one sitting, I raised my head to look out the window and was surprised to find sunny, warm California instead of the bleak snow.

"Mantra" did not come so easily to me. The opening scene with the first morning prayer, Ranshin's name, and her history came to me fully formed. After that 'she' didn't speak to me for two years. I had not idea what to do, so I began to share it with people that came to my readings. I asked them what they thought happened to her. There were several possible outcome. In the end I had Ranshin retell the story of how Prince Siddhartha, the young Buddha, left his life of luxury to become a monk. I made up the name Ranshin. It means "heart of chaos." Not chaos like my desk, but the primal chaos before land, sky and ocean are cleaved from one another—the chaos of creation and creativity. As in Prince Siddhartha's tale, Ranshin goes out of her compound and sees the dead, the aged, the ill and finally a holy person, in the form of Jon Chin. (We meet him/her in "Your Documents, Please.") In many ways I feel that today's world is similar to that of the world that Prince Siddhartha grew up in. There is great wealth and poverty. Many spiritual practices vie for their 'rightful place' and influence over the power elite. Where is the place for spiritual people when they find their own institution is a corporate machine? I don't know what happens to Ranshin after she leaves the Order. Maybe I will weave that tale in the future.

"Love" was another difficult one, one that came to me when a friend of mine submerged herself in a relationship with a man who came to rule her life. She seemed to change, became weak, emotionally distant and judgmental and seemed to cut herself off from the hearts of her friends who loved her. I was confused and upset, yet I knew it wasn't my place to say anything. It wasn't just her. I had seen other people suffocate in unhealthy relationships that seemed to hide in plain sight, camouflaged behind politically correct SM buzz-words and terms of consensual kink. I wanted to write a story that captured an unhealthy extreme of profound codependency.

Hans Daughter

2109

Midori

Author's Notes

In "The Nurse," do the Taira Corporation, Erudon Taira and Rachel Taira sound familiar? They should sound like the Tyrell Corporation, Eldon Tyrell and Rachael Tyrell. At first I had a story in mind of a sick, mutually dependent relationship between a grabber and a wealthy old man. Once I decided to make it an imagined prequel to *Bladerunner/Do Androids Dream of Electric Sheep?* it got really interesting. In my story Rachel is still alive and before she dies her memory is implanted into an android. Once the Old Man finds out, and what he decides to do with Erudon, or Erudon with the Old Man, is a yet-untold story.

As for the various sex toys, fetishes and tech perversions, do they reflect my personal tastes? What do you think?

ACKNOWLEDGMENTS

An earlier draft of the story "Master Han's Daughter" originally appeared in *Asian Fever* magazine, 2000. This version is updated and expanded.

"Aya's Blade" originally appeared in the anthology *Tough Girls* edited by Lori Selke (Black Books, 2001).

All other works are original for this collection.

I am hugely grateful to Cecilia Tan of Circlet for her patience and inspired writer-wrangling. She also provided me my personal writer's retreat hide-away complete with hot and cold running cats so I could finish the book in peace. A writer could not ask for a better handling by a publisher.

To the devilishly brilliant Ernest Greene, my thanks for your friendship, great stories and the original story commission that conceived this book. I guess this makes you a father to this freaky, twisted book. How fitting.

Kelly, I can't thank you enough for your understanding, love and putting up with the creative process. Thanks for all the great research help. So how exactly do you feel now that you have an even deeper idea of my twisted sexual mindscape?

Michele Serchuk, an inspired erotic photographer and my best friend, with whom I've collaborated creatively for years. Thank you for that wonderful cover photo of me!

To all my friends whose bodies, desires, histories, and fantasies you let me hijack to form the deviants in this book. I owe you all a drink or something. I'm sure we can negotiate some fitting compensation!

Thank you to those who came to my book readings and let me workshop the unfinished pieces on you. Your comments and ideas were pivotal in my fantasy crafting.

And finally to you, dear reader, thank you for taking a trip into my mindscape. Please feel free to drop me a line via my web site if you feel so inspired. I'd love to hear from you! (www.FHP-inc.com)

ABOUT ME

I'm a big dork who leads a charmed life. I get to do what I love surrounded by great friends who love me, and my beloved and adoring—if slightly strange—cats.

I guess I'm an idealist, very much like the rest of my family. I believe that individuals, myself included, can make a positive impact on the world with everything that we do. (OK, some days it's harder to believe in that then not, but I get over it.) I believe that being true to oneself is the first step in that.

What I do for a living and what I'm passionate about are one and the same. Somehow I managed to get lucky and be able to make a living traveling and teaching/speaking about adventurous sex. I get to teach about love skills, pleasure ways, mindful sensuality and hotter relationships. You might see me presenting or performing at organizations, universities, nightclubs, art institutes, shops and different events.

From time to time I do large-scale rope-based art installations and wild performances. Some times they're at fetish clubs, some times they're at formal galleries and museums. My creative side gets to explore in large-scale enveloping installations and photography. I'm trying to find time to work on my art site. Soon, soon....

If you're jacked-in, look for me in these usual haunts:

Classes: www.FHP-inc.com,
Rope Classes: www.RopeDojo.com
Art: www.Ranshin.com
Blog: http://fd-midori.livejournal.com

Best Fantastic Erotica

edited by Cecilia Tan

Best Fantastic Erotica is the result of the first annual contest seeking the "best short stories to combine erotica with fantasy or science fiction." The editors received hundreds of manuscripts from nearly every English-speaking country in the world, including the Usa, Canada, New Zealand, South Africa, Australia, and the United Kingdom.

The stories run the gamut from lush fantasies to sharp futuristic jabs, each one exceptional in some way. "I wanted a way to raise the bar a little, and to energize the writing community in the wake of the Bush re-election," says editor Cecilia Tan, the founder of Circlet Press. "Between the conservative swing in attitudes and the just plain boring ruts the erotica market is currently in, I wanted to offer an incentive for writers to be more daring."

Narrowing down the selections took over six months, though in the end a clear winner, "Monsoon" by Vancouver-based writer Arinn Dembo, emerged.

Writing/Reference
$19.95
ISBN 1-885865-45-7
Trade paper,
5.5" x 8.5", 336 pages

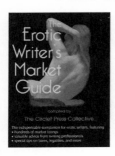

The
Erotic Writers Market Guide

by The Circlet Press Collective

Six years in the making! This reference volume combines up-to-date market listings with advice from editors and professional erotica writers on how to write and publish erotic stories, poems, or articles, choose a pseudonym, promote yourself and more. Whether you write erotica just for your own pleasure, or your lover's, and now want to share it with the world, or if you want to pursue a career as a freelance writer, The Erotic Writers Market Guide is full of tips, advice, outlets, and more.

The Erotic Writers Market Guide has listings of book publishers, magazines, online/web magazines that pay, as well as outlets for creative nonfiction like newspapers, newsletters, and other periodicals. In all, over 200 paying markets are listed.

The Erotic Writers Market Guide combines the expertise of several professional erotica writers, including David Laurents, Rachel Kramer Bussel, Cecilia Tan, and others.

Writing/Reference
$19.95
ISBN 1-885865-45-7
Trade paper,
5.5" x 8.5", 336 pages

Man With A Maid

And Other Victorian Stories

by Anonymous

Erotica/Victoriana
$14.95,
ISBN 1-885865-48-1
Trade Paper
Pages: 384
5 1/2" x 8 1/2"

The classic Victorian erotic novel, reprinted with selections from The English Governess, The Pearl, The Boidoir, and many more of victoriana's 'greatest hits.'

Nymph

by Francesca Lia Block

Fiction
$9.95
ISBN: 1-885865-43-0
Pages: 128
Format: Trade Paper
4" x 6"

Block (*Weetzie Bat, Dangerous Angels*) now gives her grown-up fans some bedtime reading of their own with this erotic, dream-like collection.

Sex Noir

Stories of Sex, Death, & Loss

by Jamie Joy Gatto

Erotica
$24.95
ISBN: 1-885865-41-4
Pages: 160
Format:Cloth
5" x 7.5"

A sensuous work on love, death, and New Orleans, and the passion that longing itself can be.

Erotic Fantastic

The Best of Circlet Press 1992 - 2002

Edited by Cecilia Tan

Circlet has always defined a new genre of erotica: erotic science fiction and fantasy. Twenty three of the finest examples from Circlet's publications.

Erotica/Science Fiction
$19.95
ISBN 1-885865-44-9
Pages: 344
Format: trade paper
Trim Size: 5 1/2 x 8 1/2"

The Velderet

A Cybersex S/M Serial

by Cecilia Tan

On a faraway planet, two roommates start to explore the forbidden world of SM/bondage. What they learn could save their world from destruction.

Erotica/Science Fiction
$14.95
ISBN: 1-885865-27-9
Pages: 192
Format: trade paper
5 1/2" x 8 1/2"

Sextopia

Stories of Sex and Society

edited by Cecilia Tan

Catherine Asaro, Suzy McKee Charnas, M. Christian, Raven Kaldera, and others contribute to this hot and insightful anthology.

Erotica/Science Fiction
$14.95
ISBN: 1-885865-31-7
Pages: 208
Format: trade paper
5 1/2" x 8 1/2"

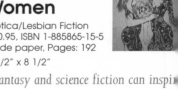

ORDER FORM

Please send me these titles:	Qty	Price	Subtotal
Best Fantastic Erotica		$19.95	
Master Han's Daughter		$12.95	
Erotic Writers Market Guide		$19.95	
Man With A Maid		$14.95	
Nymph (pb)		$9.95	
Sex Noir (hc),		$24.95	
Mind & Body		$14.95	
The Darker Passions: Carmilla		$14.95	
The Darker Passions: Jekyll & Hd.		$14.95	
The Darker Passions: Frankenstein		$14.95	
The Darker Passions: Dracula		$14.95	
Wired Hard 3		$14.95	
Wired Hard 2		$14.95	
Through A Brazen Mirror		$14.95	
Things Invisible to See		$12.95	
The Drag Queen of Elfland		$10.95	
Dyke The Halls		$12.00	
Stocking Stuffers		$12.00	
Selling Venus		$9.95	
Virtual Girls		$7.95	
Stars Inside Her		$14.95	
The NEW Worlds of Women		$10.95	
SexMagick		$7.95	
SexMagick 2		$9.95	
Sextopia		$14.95	
Sexcrime		$14.95	
Erotic Fantastic		$19.95	
The Velderet		$14.95	
(+ 5% Tax, MA residents only)			
Plus Shipping			
Total			

Are You a Bookstore? YES NO
Are You an Individual? YES NO
Ship to:_____

Buyer Name: _____
Phone: _____
Email:_____

Credit Card Info: Exp Date:___/__

_____-_____-_____-_____

X _____
(sign here)
By this signature I warrant that I am over
18 years of age.

Individual orders: don't forget to include shipping and
handling. Within the USA add $4.50 shipping for the
first book, $1.50 for each additional book. For shipping
to Canada, include $5 plus $1 for each additional book.
For overseas, include US$6 plus US$2 per book for air-
mail shipping. (We do not recommend shipping by sea
mail.) Allow 4-6 weeks for delivery in US/Canada, 6-8
weeks overseas.
We accept VISA and MasterCard.

Circlet Press
1770 Massachusetts Avenue, Suite 278
Cambridge, MA 02140
(617) 864-0492
http://www.circlet.com